IMAGES
of America

POINT ARENA
LIGHTHOUSE

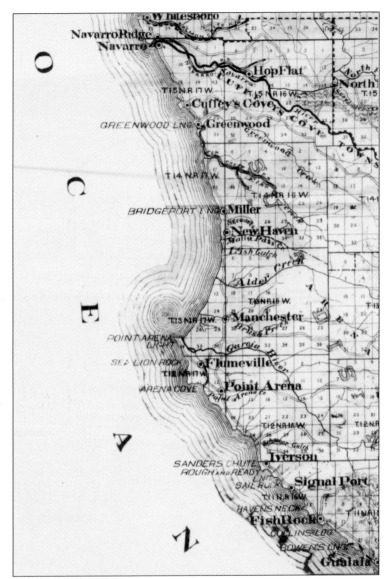

This 1902 map by J.N. Lentell shows "Point Arena Light" where the lighthouse is located and a circular line indicating submerged Arena Rock. The central area of the map also shows the location of the town of Point Arena and Arena Cove. The rocks and abrupt change in the direction of the coastline require ship captains to adjust course 40 degrees to the northeast when heading north and 40 degrees to the southeast when heading south along the coastline. Failing to do so has proved hazardous to mariners over the years. Point Arena Lighthouse is located at latitude 38° 57′ 10″ N and longitude 123° 44′ 42″ W. (Courtesy Cheri Carlstedt.)

ON THE COVER: This is a fine photograph of the original 1870 Point Arena Lighthouse tower and keepers' dwelling. The identities of the three men in the image are unknown. The lighthouse tower was built of brick and mortar in a conical design. A first-order Fresnel (pronounced *Frahnell*) lens was mounted in the lantern room at the top of the tower. The dwelling was constructed in a Stick and Gothic Revival style and housed the head keeper, up to three assistant keepers, and their families. (Courtesy Point Arena Lighthouse.)

IMAGES
of America

POINT ARENA
LIGHTHOUSE

Merita S. Whatley

Merita S Whatley

Mike Epanchin

ARCADIA
PUBLISHING

Published by Arcadia Publishing
Charleston, South Carolina

Printed in the United States of America

Library of Congress Control Number: 2012952108

For all general information, please contact Arcadia Publishing:
Telephone 843-853-2070
Fax 843-853-0044
E-mail sales@arcadiapublishing.com
For customer service and orders:
Toll-Free 1-888-313-2665

Visit us on the Internet at www.arcadiapublishing.com

To my Point Arena Lighthouse family and my own sailor guy, Richey

CONTENTS

ACKNOWLEDGMENTS

It is with my deepest gratitude that I thank Nicolas Epanchin for his assistance in creating this book by scanning and formatting photographs, his proofreading notes, and his patience with me as an author. I wish to thank Glenn Funk for his clarifying notes as a proofreader. I am thankful to Bob Carter for his photographic work on images from the past and his professional job of creating the visual storyboards in the Point Arena Lighthouse museum. Many of these photographs appear in this book. I would also like to thank Rae Radtkey and Steve Oliff for their sincere support and encouragement through the process of writing this book; their suggestions have been interesting and given life to the book.

I would like to express appreciation for the editors I have worked with at Arcadia Publishing for their patience and guidance as I have written and collected photographs for this book.

I am grateful for the experience of meeting the people who have contributed photographs and personal stories from their family albums: Shirley McMillen Beltz Zeni, Teresa Zettler, Joyce Hamilton Pratt and her brother, Harry Hamilton, William McMillen Kramer, Martha Austin McKinzie, and Sarah Owens Swartz and her lighthouse sisters, Shirley, Dixie, Joan, Jean, and Diana. They and their lighthouse families have contributed their life stories to several chapters in this book.

Finally, it is love and encouragement from my family that has always inspired and sustained me. From an early age, learning to honor and appreciate history has contributed greatly to my decision to write this book about my community and those who have passed this way before.

INTRODUCTION

Beginning in 1870, through the course of time leading to the present, the story of Point Arena Lighthouse is actually the tale of three light towers, three Fresnel lenses, two fog signal buildings, a long list of light keepers and their families, and a great earthquake that changed everything.

The setting, 23 acres on a peninsula that runs a half mile out to sea on the Mendocino coast of California north of the small town of Point Arena, was known over time as Cabo de Fortunas (Cape of Fortunes), Punta Barra de Arena (Point Bar of Sand), and eventually, Point Arena.

With the movement of lumber and goods along the coast, many ships wrecked upon submerged rocks, often due to heavy fog in the area. Early on, the Native American Mitcom Pomo people must have witnessed many sailing ships and shipwrecks off the coast. It is these ships and shipwrecks that form a dramatic maritime history of the Mendocino coast.

The abrupt angle of the California coastline at Point Arena required ship captains to adjust course by 40 degrees. Just north of Point Arena Lighthouse, the large submerged Arena Rock was an added danger to ships traveling in heavy fog along the coast.

In 1866, Congress authorized a survey of the Point Arena area by the US Lighthouse Board to determine a site for a lighthouse. The ideal location was the prominent point located a few miles north of Point Arena.

Maps and engineering plans were prepared; the new tower would be built of brick in a conical design. Construction of the tower was completed in April 1870, and a fixed first-order Fresnel lens, shipped from France, was lit for the first time on May 1, 1870.

Also completed in 1870 was the two-story, four-plex keepers' dwelling, constructed of brick in a Stick and Gothic Revival style. The first fog signal building was completed in 1871; the horns added an important navigational aid for ships traveling in the thick coastal fog. The structure was rebuilt closer to the tower in 1896 due to erosion on the point.

Fog, wind, and sea can be extreme at the peninsula where Point Arena Light Station is situated. In August 1888, the *Point Arena Record* newspaper reported "the lighthouse recorded a new record of 313 hours of constant fog. The old record—279 hours in 1875."

From the establishment of the station in 1870 until 1900, thirteen known shipwrecks occurred off the coast at Point Arena. In 1893, a bell buoy was placed a mile west of Arena Cove as an additional aid to ship traffic.

In May 1882, construction began on the road from the lighthouse to the main county road leading to Point Arena. The road was an important link between the keepers and their families at the lighthouse and the townspeople of Point Arena.

In 1903, the US Life-Saving Service established a station at Arena Cove. The cove, wire chute, and pier at Point Arena made the town a popular stop along the coast for loading lumber and ranch commodities and off-loading supplies for local merchants, the Life-Saving Station, and the lighthouse. The Life-Saving Station keeper and surfmen were well trained for daring rescues just offshore using surfboats and the breeches buoy rescue apparatus.

In 1906, everything changed when an earthquake struck San Francisco, traveled north along the San Andreas Fault, causing tremblers that leveled most of the buildings in Point Arena, and continued on to the lighthouse, where the keeper in the lantern room reported that the tower quivered, swung, and vibrated until sections could be heard grinding upon each other while the Fresnel lens "fell in a shower upon the iron floor." The keepers' dwelling was severely damaged.

By late 1906, a crew of engineers and carpenters was hired from San Francisco along with local laborers to begin the job of dismantling the once-graceful tower. A temporary tower was erected, and the lantern room from the original tower was placed on top. A second-order Fresnel lens was used in the temporary tower so that the station was not without a warning light during construction.

Engineering drawings for the new tower specified it would be constructed of steel-reinforced concrete with a wide buttress at the base to help withstand earthquakes. The new 115-foot tower began operation on September 15, 1908, with a rotating first-order Fresnel lens.

By 1912, the lumber trade had slowed, and the mill closed at Flumeville, located at the top of the road to the lighthouse. In 1928, electricity was finally extended to the lighthouse, making the keepers' job of tending the light easier. Assistant keepers, known as "wickies," no longer needed to trim the wicks in the lantern. The fog still rolled in off the sea, and rather than requiring close to 100 cords of wood annually, a diesel generator and air compressor kept the pressure ready for the powerful horns.

Beginning in 1939, the US Coast Guard assumed command of the light station and the Life-Saving Station at Arena Cove. A Long Range Navigation (LORAN) station was established south of the light station.

In 1941, the United States entered World War II. The west coast became dangerously vulnerable to invasion by Japanese submarines. After the sinking of a vessel north of Fort Bragg, the Coast Guard implemented a system of beach patrols and lookout towers monitored by enlisted men as well as civilian volunteers. Lighthouse keepers and their families were required to use blackout curtains in their homes while the tower light continued to shine out to sea.

Still, life at the station was good. Light keepers transported their children to local schools and were part of the local community. Today, adults who grew up at the station recall their families enjoying the wild beauty of the site and the excellent fishing at the mouth of the Garcia River.

The fog signal was discontinued in 1976, and new technological advancements brought an automated beacon to the tower. Over time, the tower illumination source changed. From 1870 to 1928, the lamp inside the lens was fueled by oil, kerosene, and finally incandescent oil vapor. From 1928 to the present, an electric incandescent bulb has been used to illuminate the tower beacon. The lighthouse is still an active aid to navigation. The Coast Guard Humboldt Bay continues to operate a modern VRB-25 beacon mounted outside the lantern room in 2003, replacing a 400-pound DCB-224.

In 1982, the Coast Guard announced plans to close the light station. Motivated by its intentions to keep the lighthouse open to the public, a group of local citizens began negotiations with the Coast Guard and the Department of Transportation, offering to take over management of the station. In 1986, the group formed Point Arena Lighthouse Keepers, Incorporated (PALKI), elected a board of directors, secured a lease, and hired the first station manager, John Sisto. In 2000, PALKI was deeded Point Arena Light Station No. 496.

With support from local communities, a museum was developed in the fog signal building, and the keepers' houses, built in the 1960s by the Coast Guard, were renovated and made into vacation rental cottages. A gift store was added in the entry room to the museum, and tours to the top of the tower were offered.

In 2007, PALKI board members, along with executive director Rae Radtkey, applied for and were granted funds from the California Cultural and Historical Endowment to renovate and preserve the lighthouse tower, fog signal building, two oil storage buildings, and the public restrooms. The Fresnel lens was removed from the tower and placed on display in the museum. Terms of the grant required that PALKI supply a large sum of matching funds. In order to raise money for this purpose, a fund-raising committee was formed. The Save the Light Committee worked diligently over five years to raise money toward this goal.

In the pages that follow, a photographic history of Point Arena Lighthouse unfolds. The two tall towers and first-order Fresnel lenses are prominently featured. The people who appear in the photographs help tell the story of a small town with indomitable spirit and the dedication and daily lives of those who have taken part in saving the light at Point Arena Lighthouse.

One

WHY A LIGHTHOUSE
AT POINT ARENA?

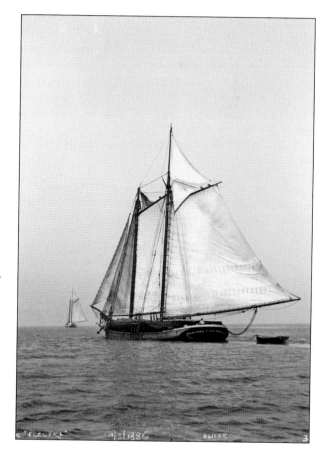

The lumber schooner *Electra* is pictured here. With the discovery of gold in 1848, San Francisco began to grow into a major seaport. Gold seekers caused a population explosion in northern California. The Great Earthquake of 1906 necessitated rebuilding San Francisco, and lumber schooners, like the *Electra*, moved redwood and Douglas fir from north coast forests and delivered goods to small lumber towns where commerce was thriving. (Courtesy Point Arena Lighthouse.)

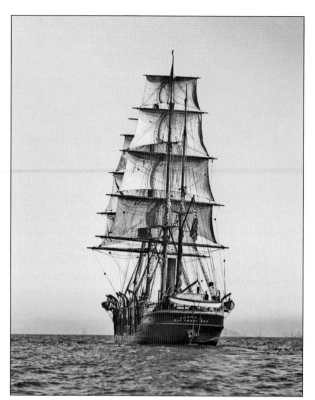

In the 18th and the 19th centuries, whaling ships like the *Narwhal*, a steam-powered barque, sailed from whaling grounds in the Pacific to the Arctic and returned to the ports of Oakland and San Francisco. She was regarded as the prize of the San Francisco Bay whaling fleet. The *Narwhal* went through many transformations; she was used in the movie *Sea Beast* in 1926 starring John Barrymore. (Courtesy Point Arena Lighthouse.)

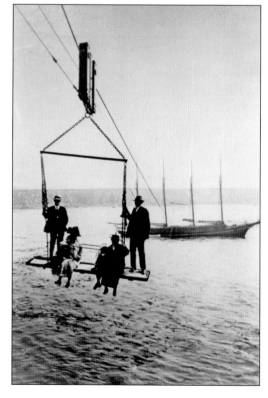

Advertisements in newspapers from San Francisco to points north assured folks that visiting the coast by ship was the "most comfortable" way to travel. In this photograph from 1916, Capt. S.O. Mitchell and his family disembark via "the wire trapeze" after several days of rolling on the waves. It must have been a thrill, though they look so at ease. (Courtesy Wasserman collection.)

Pictured is lumber schooner *Big River* in the 1880s. Schooners were more maneuverable than the old square riggers and required smaller crews. With a shallow draft and sturdily built, the *Big River* joined *Electra*, *C.A. Thayer*, and many others in transporting lumber out of "dog-holes," the small coves and ports on the north coast of California. (Courtesy Point Arena Lighthouse.)

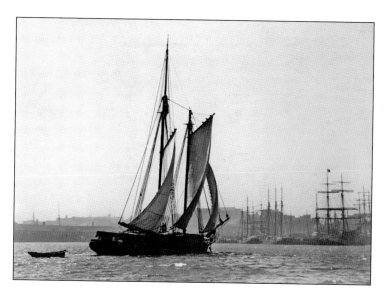

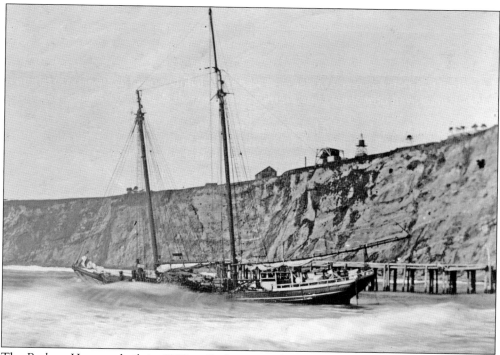

The *Barbara Hernster*, built in 1887 in Fairhaven, California, was a gasoline-powered dog-hole schooner. According to *Congressional Record*, she was "blown ashore" at Point Arena on January 24, 1901. In this July 1901 photograph, she has been refloated and is being towed out of Arena Cove into deeper water. (Courtesy Wasserman collection.)

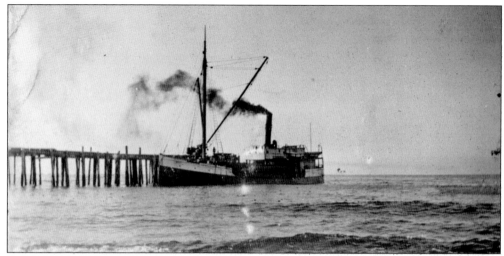

By 1880, steam engines were added, and a new vessel, the coastal steamer, was born. Sails disappeared, and steamers like the *Sea Foam*, pictured at the Arena Cove pier, were joined by the *Weott, Pomo, Point Arena,* and *San Benito,* which took the place of schooners in shipping lanes along the north coast of California. Fast and capable of transporting large loads of lumber and supplies, they were the efficient workhorses of the shipping trade. (Courtesy Point Arena Lighthouse.)

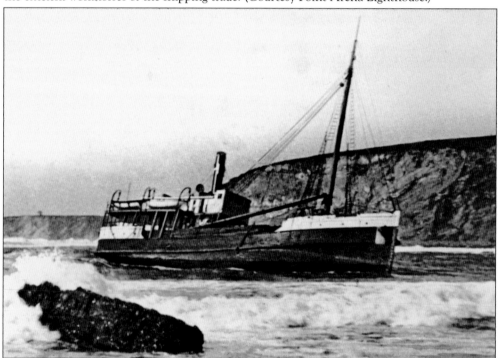

The original West Coast *Sea Foam* wrecked at Westport, California, in September 1885. The second *Sea Foam,* above, was built in 1904 and measured 127 feet. She was well regarded by the people of coastal towns for transporting goods, lumber, and passengers. The *Point Arena Record* reported, "It was great to hear the whistle of the *Sea Foam* as they arrived with 300 tons of provisions for the town." Sadly, she went aground on the rocks at Arena Cove in February 1931. (Courtesy of Point Arena Lighthouse.)

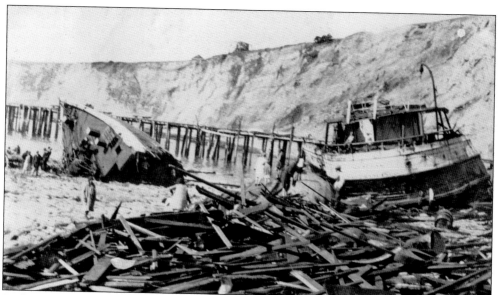

In the 1931 photograph above, people walk among the wreckage of the *Sea Foam* and watch as the once fine little steamer (photograph below) deteriorates on the rocky beach of Arena Cove. In her day, people of the coast depended on coastal steamers; shares in the *Sea Foam* were sold to coastal merchants to assure that their goods were loaded with her cargo. (Both, courtesy Point Arena Lighthouse.)

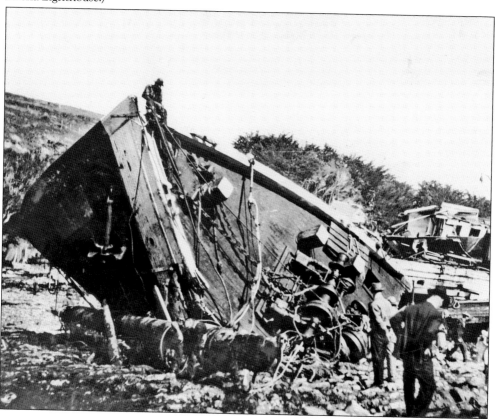

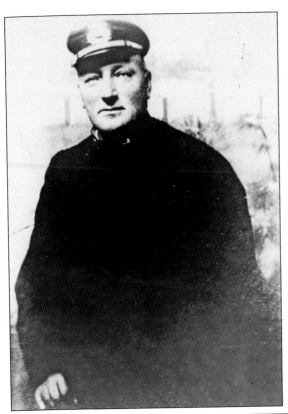

"Between 1858 & 1880, 15 vessels wrecked off Point Arena," reported the *Point Arena Record* in 1884. The *San Benito* (seen below) with Capt. Axel Hendricksen (left) met their fate at Point Arena in November 1896. Twenty-six years after the Point Arena Lighthouse was built, the good captain confused the tower light for an electric light farther north at Elk and steered into the rocks. In the bottom image, crewmembers are seen clinging to the rigging on the sinking ship. Reports of a desperate rescue vary: one claims that all but five men aboard the steamer were saved, for which Captain Hendrickson received an award for heroism, the other that 30 men perished in the wreck. (Both, courtesy Point Arena Lighthouse.)

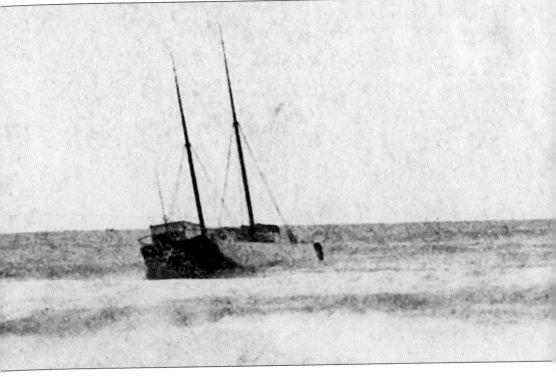

The SS *Australia*, underway, was built in Glasgow, Scotland, in 1875. The 376-foot barquentine, rigged for sail, was four-masted with one funnel. Under British registry with British officers and a Chinese crew, she transported passengers and cargo between San Francisco, Auckland, and Sydney with calls in Honolulu and Fiji. Like many fine ships, the *Australia* had an eventful and ultimately sad history. In 1905, the *Australia* was chartered to the Russian government and captured by the Japanese while carrying supplies from the United States to Siberia. (Courtesy Point Arena Lighthouse.)

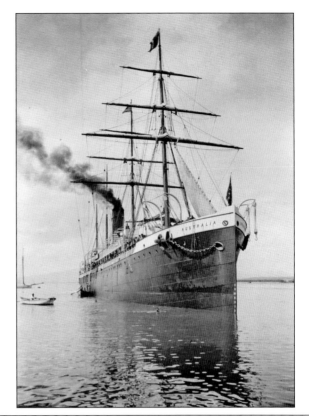

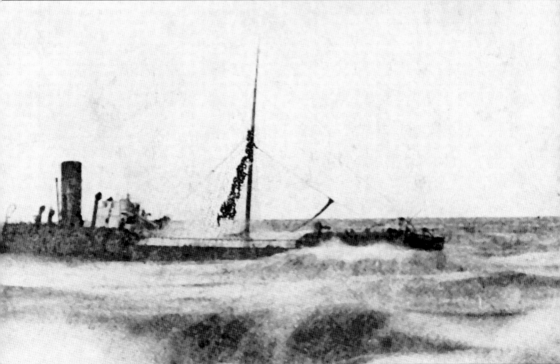

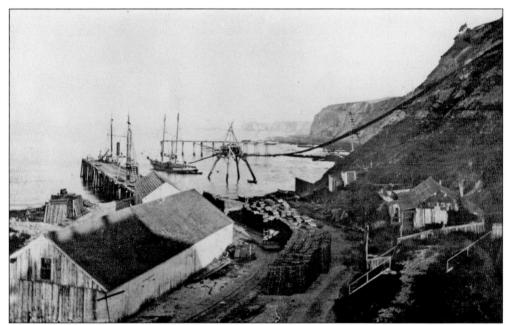

Point Arena had the advantage of a protected mooring site for ships. In the early 1860s, small boats called "lighters" carried freight to waiting schooners outside Arena Cove. The first wharf or pier was built in 1866, and a gravity chute followed; both can be seen in the photograph above and in a closer view (below) of the chute from which ships could be loaded. Farm products and animals were loaded along with lumber from local mills. Gravity chutes, and later wire chutes, were a West Coast invention because of high cliffs and lack of harbors. The commerce was great, but sailing vessels continued to go aground. Finally, in June 1866, Congress approved building a lighthouse at Point Arena. (Both, courtesy Point Arena Lighthouse.)

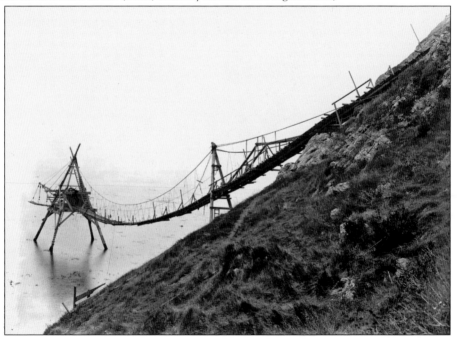

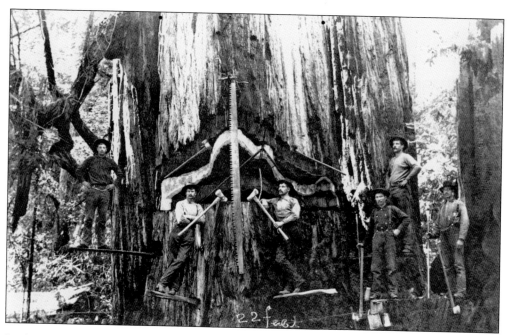

In the photograph above, taken in the early 1890s, loggers poised to cut down a tree stand on a platform erected on the trunk of a giant redwood. After cutting through the bark, a 10-foot falling saw was used to complete the task. It took a day and a half to fell a large redwood with this hand method. In the photograph below, loggers and businessmen ride on top of a giant redwood log being transported to a mill by railcar. In just a few years, from 1849 to the mid-1860s, West Coast communities changed from sites of relative serenity to bustling seaports and municipalities due to gold-seekers, loggers, businessmen, homesteaders, and curious travelers arriving by ship. (Photographs by A.O. Carpenter; both, courtesy of Mendocino Historical Museum.)

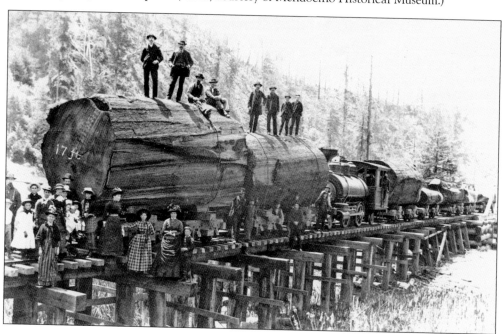

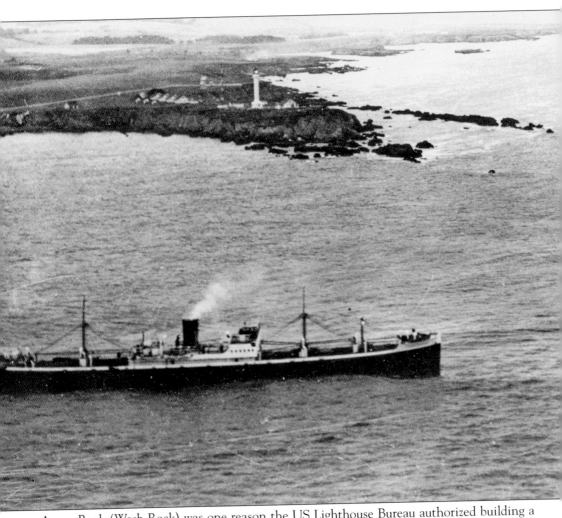

Arena Rock (Wash Rock) was one reason the US Lighthouse Bureau authorized building a lighthouse at Point Arena. The huge rock has a surface area of 1.24 acres. Submerged six feet under water at high tide and lying 1.5 miles offshore, it has a unique ecosystem and has snagged numerous ships' hulls over the centuries. Here, on September 9, 1949, the 700-foot-long *Pacific Enterprise*, a British freighter, lies grounded on Arena Rock. A thick fog shrouded the shoreline, the tower light was on, and the fog signal horns called a warning of rocks nearby. The ship's captain, M.E. Cogle, a 40-year veteran on his final voyage before retirement, believed he was just off the Farallon Islands, 20 miles south of Point Reyes. All passengers and crew made it safely to shore. Some ships could be refloated on a high tide after grounding. The *Pacific Enterprise* was not so lucky; the ship broke into pieces on Arena Rock. (Courtesy Shirley Zeni.)

Two

First Lighthouse
at Point Arena, 1870

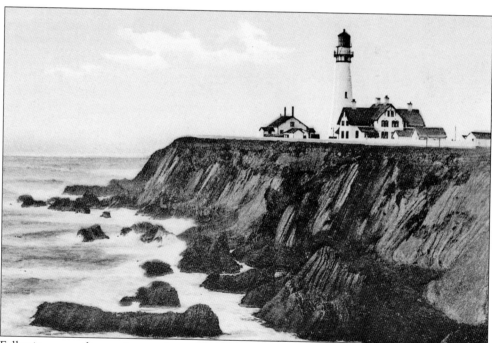

Following years of increasing numbers of shipwrecks along the Mendocino coast, the US Lighthouse Service determined, in 1866, that a lighthouse was needed at Point Arena. Construction of the tower, fog signal building, and keepers' dwelling began in 1869. The fog signal building was constructed with wood, and the conical tower and dwelling were constructed with brick and mortar. The tower and dwelling were completed and opened in 1870, and the fog signal building followed in 1871. (Courtesy Point Arena Lighthouse.)

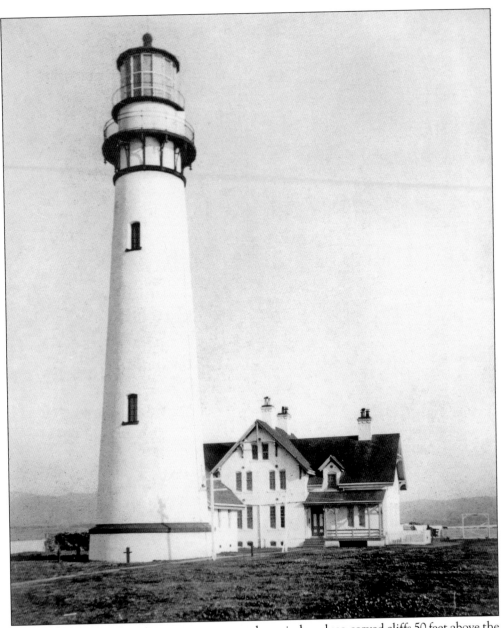

A 100-foot tower at Point Arena was constructed on wind- and sea-carved cliffs 50 feet above the rocky shores of the Pacific Ocean. The brick tower was an elegant conical design, whitewashed, with a red roof and ornate black ironwork supporting the gallery just below the black lantern room. The lantern room housed a fixed first-order Fresnel lens. The two-story keepers' dwelling was designed in a stately Stick and Gothic Revival style. Lighthouses Point Arena, Pigeon Point, and Piedras Blancas, built in a typical Atlantic Seaboard style, earned the three tall beauties the unofficial title of West Coast "sister" lighthouses. (Courtesy Point Arena Lighthouse.)

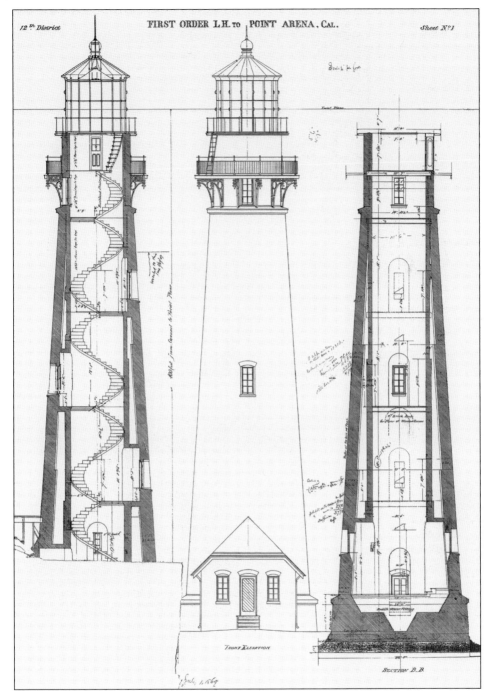

This engineering drawing illustrates the interior and exterior of the tower built at Point Arena Light Station No. 496. This specific drawing was later used during the demolition of the original tower in 1907; a note near the left cross-section says, "wrecked to this line 1/31/07." This cross-section also shows the spiral staircase in the tower. A diamond-shaped bronze plaque imbedded in the lower step of the actual staircase reads, "Calvin Nutting & Son—Makers—1869—San Francisco." (Courtesy Point Arena Lighthouse.)

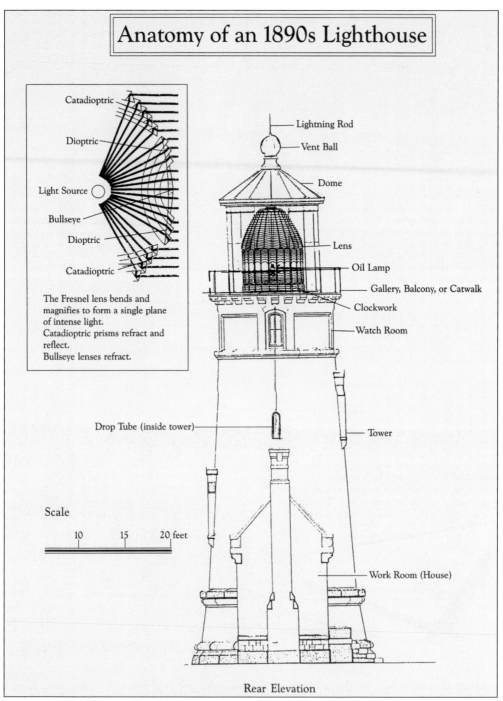

Anatomy of an 1890s Lighthouse

Catadioptric

Dioptric

Light Source

Bullseye

Dioptric

Catadioptric

The Fresnel lens bends and magnifies to form a single plane of intense light.
Catadioptric prisms refract and reflect.
Bullseye lenses refract.

Lightning Rod

Vent Ball

Dome

Lens

Oil Lamp

Gallery, Balcony, or Catwalk

Clockwork

Watch Room

Drop Tube (inside tower)

Tower

Scale

10 15 20 feet

Work Room (House)

Rear Elevation

This drawing illustrates the "Anatomy of an 1890s Lighthouse" with an inset in the upper left corner in which both dioptric and catadioptric lens prisms are illustrated. (Courtesy Point Arena Lighthouse.)

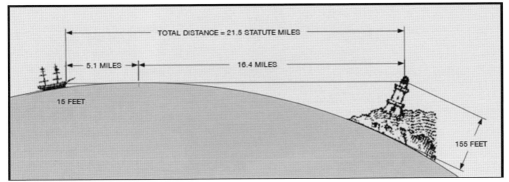

This graphic illustration explains why an effective lighthouse must be of significant height and erected on a rock or tall cliff in order for the beacon of light to be visible to marine traffic as far out to sea as possible. As shown, one consideration is allowance for the curvature of the earth over a distance of 21.5 statute miles. In the illustration, the lens focal point is 155 feet above mean sea level. To an observer on the deck of a ship, the light should be visible for 21.5 statute miles, assuming the beacon of light is adequate and atmospheric conditions are ideal. (Courtesy Point Arena Lighthouse.)

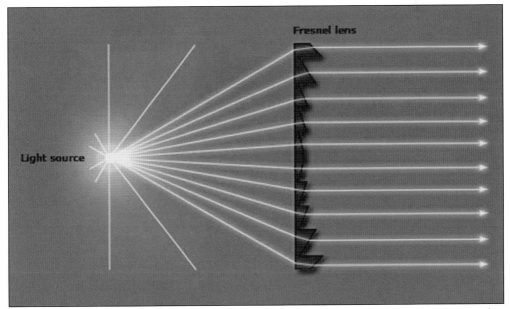

This illustration depicts how light is refracted by the dioptric prisms of a Fresnel lens mounted in the lantern room on top of a lighthouse and powerfully illuminated from within. All light rays exit the lens horizontally, directing them seaward. (Courtesy Artworks Florida.)

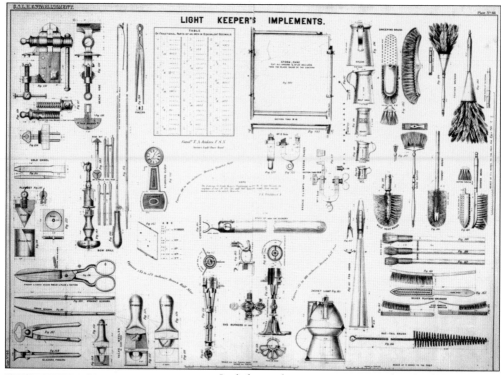

Lighthouse keepers were required to do all light repair work at the station. Of prime importance in this role was the maintenance and repair of the beacon mechanism and the fog signal apparatus. Major repairs were contracted out or done by Lighthouse Service tender crewmembers. The light keeper's tools in these two illustrations are mostly related to maintaining the lantern, lens, and related mechanism. (Courtesy Point Arena Lighthouse.)

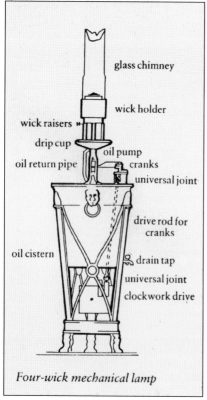

Four-wick mechanical lamp

glass chimney

wick holder

wick raisers

drip cup

oil return pipe

oil pump

cranks

universal joint

drive rod for cranks

oil cistern

drain tap

universal joint

clockwork drive

A Funck's Hydraulic Float Lamp, pictured at left, was a four-wick mechanical lamp like the one used inside the original first-order lens in the tower. According to Lyman L. Palmer in *A History of Mendocino County*, "The lamp consists of two chambers of oil, one above the light and one below. The oil is pumped from the lower to the upper" passing "through a chamber in which there is a regulating float" governing the flow of oil to the lamp. In the image at right, a "reflecting arrangement is constructed about the lamp, so that every ray is brought to the focal plane to warn the mariner of dangers, and to guide him safely into the quiet harbor." (Courtesy Point Arena Lighthouse.)

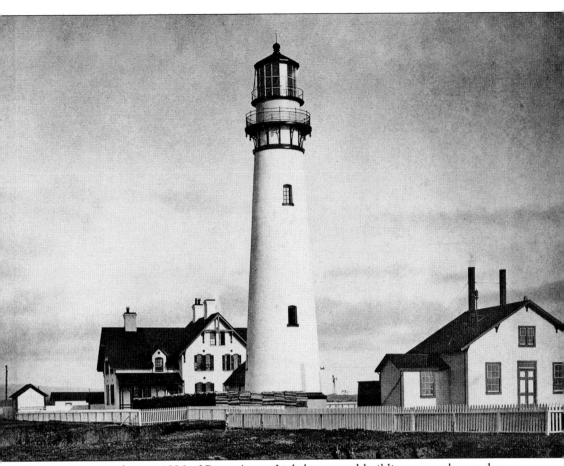

This picture was taken in 1896 of Point Arena Lighthouse and buildings near the northern boundary of the light station. The fog signal building is shown reconstructed after the original 1871 building was threatened by erosion on the tip of the peninsula where it was located for 26 years. (Courtesy Point Arena Lighthouse.)

The foghorn at the station was originally powered by steam under pressure. The wood-fired boiler consumed nearly 100 cords of wood per year. Shown here is a diesel generator used in the fog signal building along with an electric compressor to generate air under pressure to operate the horns. Point Arena's foghorn was discontinued in 1976. (Courtesy Owens family collection.)

Three

LIFE-SAVING STATION AT ARENA COVE, 1903

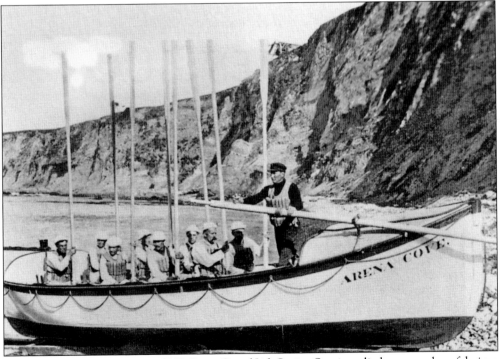

The US Life-Saving Service and US Coast Guard Life Saving Service relied on a number of designs of surfboats and lifeboats at Life-Saving Stations in the United States. This classic photograph from 1914 shows the cork-vested keeper and surfmen of the US Life-Saving Station at Arena Cove as they perform a sea rescue drill in the station's graceful and highly efficient surfboat. (Courtesy Mendocino County Historical Society.)

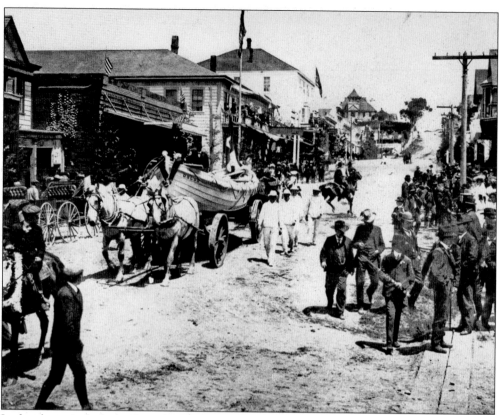

In the photograph above, the station keeper and eight surfmen of the Life-Saving Station proudly show off their surfboat during the Fourth of July parade down Main Street in Point Arena in the summer of 1904. In the bottom photograph, the men of the Life-Saving Station haul a rescue boat up onto the ways of the boathouse at Arena Cove. The boat sits on a boat carriage and is guided along rails up into the interior of the boathouse. (Both, courtesy Wasserman collection.)

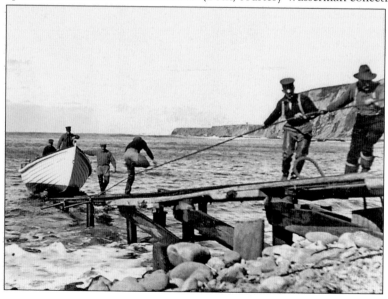

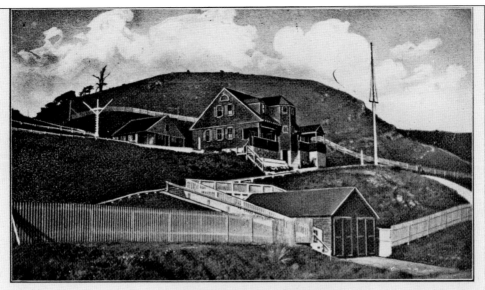

Life Saving Station at Point Arena.

This 1920 postcard (above) of the Life-Saving Station at Arena Cove shows the main station house, the extensive hillside fencing, and the original boathouse below. The property was eventually sold at auction by the government in 1962. In the 1980s, Richard Wasserman purchased the station property and restored the buildings, retaining architectural features of the original design. The property is listed in the National Register of Historic Places. Keeper Henry Smith (right) was in charge of the Golden Gate Life-Saving Station. On September 13, 1902, he was transferred to the Life-Saving Station at Arena Cove. Keeper Smith wears a fine example of a Life-Saving Service uniform from the early 20th century. (Above, courtesy Wasserman collection; right, courtesy Point Arena Lighthouse.)

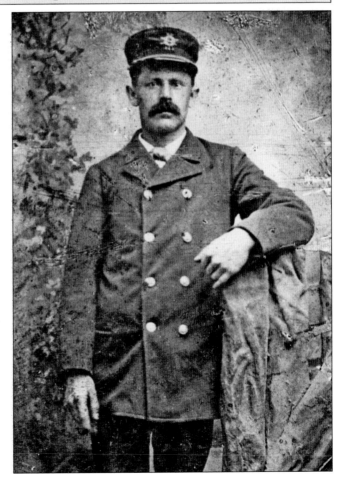

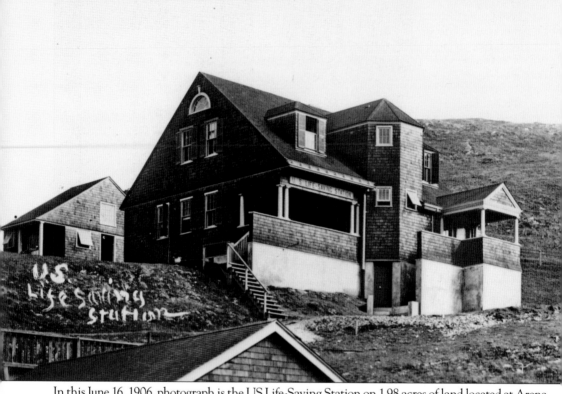

In this June 16, 1906, photograph is the US Life-Saving Station on 1.98 acres of land located at Arena Cove in Point Arena, California. The station was built in modified Port Huron architectural style, typically found in Great Lakes and East Coast regions. The wooden station house accommodated the keeper and surfmen. The keeper's family often lived in the house or nearby. Rooms included a living room off the front porch, dining room, kitchen, lower bedroom or office, and three bedrooms on the upper story reached by a narrow staircase inside the modified tower in the front. The full basement, reached by lower stairs in the base of the tower or from the outside lower door in front, was designed with bathing facilities for the men with a unique gutter system around the perimeter of the cement floor for drainage. (Courtesy Wasserman collection.)

The beach apparatus cart, containing the Lyle gun, is moved into position for an on-land drill. The breeches buoy is a large life ring that is suspended from a hawser or cable stretched from a point on land to the stricken ship. The cable to the ship is put in place by use of the Lyle gun, named after David Lyle, who invented it. (Courtesy Wasserman collection.)

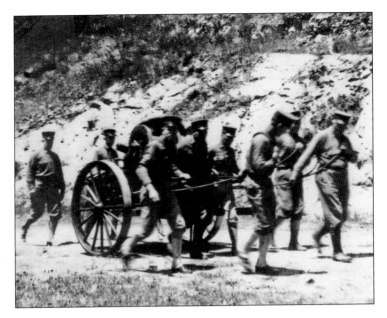

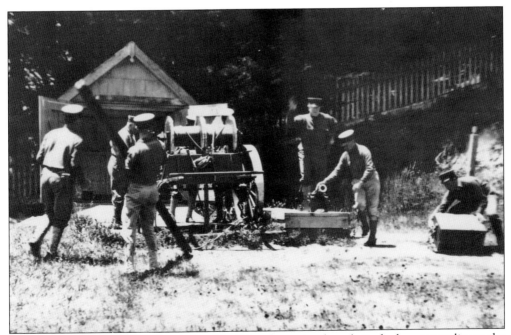

The Lyle gun is being prepared and placed for firing the projectile and attached messenger line to the stricken ship. Once the messenger line is received on the ship, it is used to pull a cable from shore to the ship and back again. During the breeches buoy drill, the projectile fired from the Lyle gun is aimed through a drill pole to practice accuracy of the shot. (Courtesy Wasserman collection.)

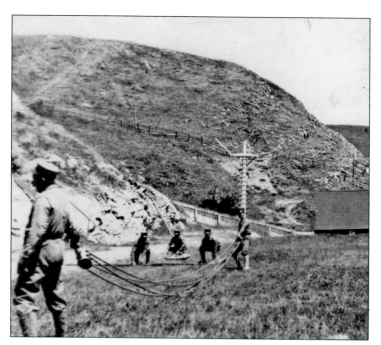

Pictured is the laying of the block and tackle, which is used to tighten the cable between the shore and ship in order to support the weight of crewmembers and passengers during the breeches buoy rescue. The cable was placed over the crotch of two lashed poles then tightened with the block and tackle. (Courtesy Wasserman collection.)

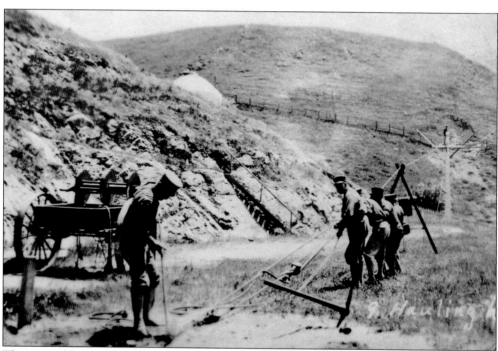

The taut cable is ready for use to transport rescued crewmembers and passengers from ship to shore on the breeches buoy. A bipod, called a crotch pole, is shown that elevates and secures the cable as it extends from the ship to the shore. The breeches buoy travels toward shore along the cable on a pulley and is then sent back to the ship. Light lines are used to pull the breeches buoy along the cable. (Courtesy Wasserman collection.)

Seen are surfmen with apparatus in place for the breeches buoy drill. One man is inside the breeches buoy being transported by cable toward the surfmen on shore, waiting to release him and send the lifesaving gear back for another shipwrecked passenger or crewmember. The method was slow but effective for rescues just off shore. (Courtesy Shirley Zeni.)

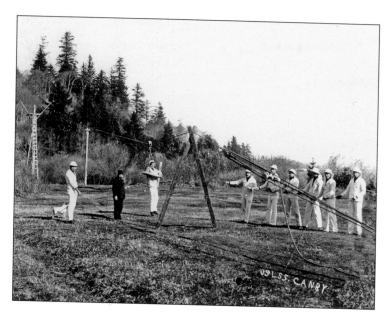

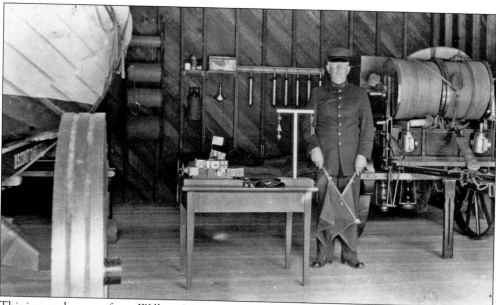

This image shows surfman William Marsten inside the original boathouse, sometimes referred to as the "upper boathouse," after the newer one was constructed on the water at Arena Cove. The Monomoy rescue boat is on a cart at left, surfman Marsten is in the center with signal flags and projectiles for the Lyle gun on the wall behind him, and the beach apparatus is at right with large reels of line used in breeches buoy rescues. In the 1950s, the Coast Guard helicopter replaced the breeches buoy for sea rescues. (Courtesy Wasserman collection.)

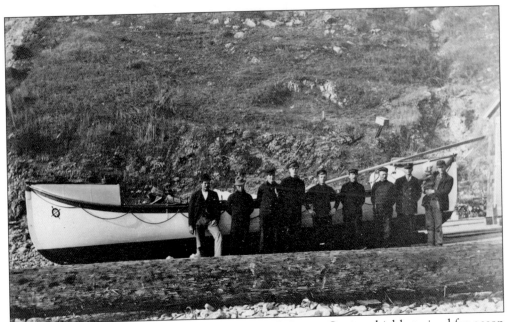

In this photograph, surfmen and officers of the Life-Saving Station, highly trained for ocean rescues, are standing by a lifeboat with the official Life-Saving Service emblem on the bow. The long oar in the rescue boat is the "sweep," used for steering and manned by the keeper; the shorter "strokes" were oars manned by surfmen. At Arena Cove, beginning in 1901, the Monomoy surfboat—a double-ended, lapstrake design of cedar over oak framing with spruce spars, measuring 23 feet to 26 feet—was easily pulled on a cart by surfmen from the boathouse to the water's edge. A longer, unsinkable, self-bailing lifeboat was also used. After the Coast Guard began operating the station, a motorized lifeboat was introduced for increased safety and speed during rescue missions. Below is a 1921 photograph of the lookout at Hunter's Point on the north-side bluff above Arena Cove, used by the Life-Saving Station to watch for mariners in distress before World War II. It was also used as a lookout for foreign ships, submarines, and airplanes. (Both, courtesy Wasserman collection.)

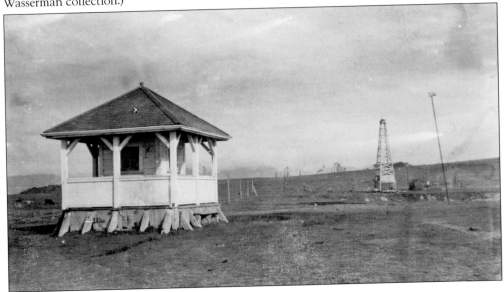

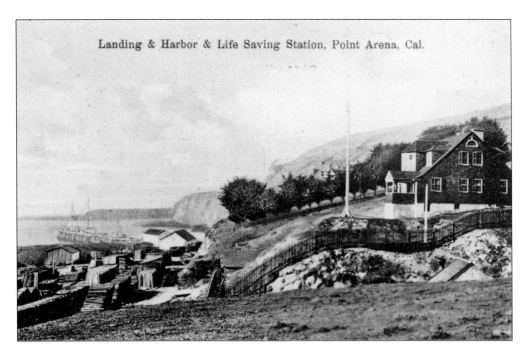

Landing & Harbor & Life Saving Station, Point Arena, Cal.

The above photograph is of the Life-Saving Station above Arena Cove. The exterior of the buildings remained unpainted during operation by the US Life-Saving Service. In the image below, the station is as it appeared after 1915, when the Coast Guard began operating the station and required all wooden structures to be painted in a traditional scheme of white walls, red roof, and gray trim. Out at the lighthouse, beginning in 1939, the Coast Guard directed the enlisted men to paint equipment gray, including the bronze and highly polished brass so carefully maintained by light keepers over the years. (Both, courtesy Wasserman collection.)

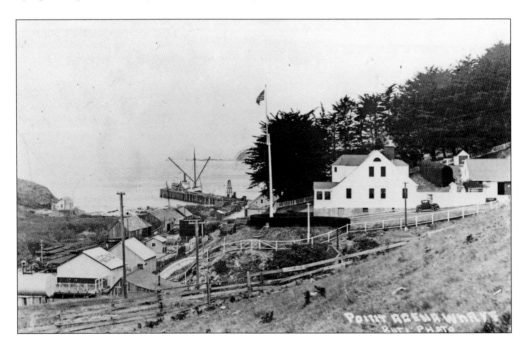

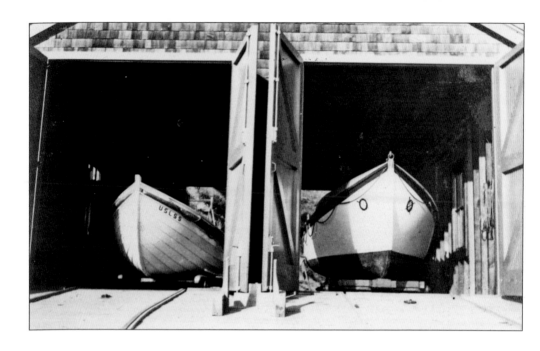

Above, the heavy doors are opened wide on the original boathouse with the Monomoy and a lifeboat at the ready in the event that a rescue must be made off the coast at Point Arena. The men at the station pulled the boats to the water's edge and launched them. Below, the station is as it looked during the Coast Guard years. The Quonset hut, top left, built during World War II, was a recreation and staging area for the men. (Both, courtesy Wasserman collection.)

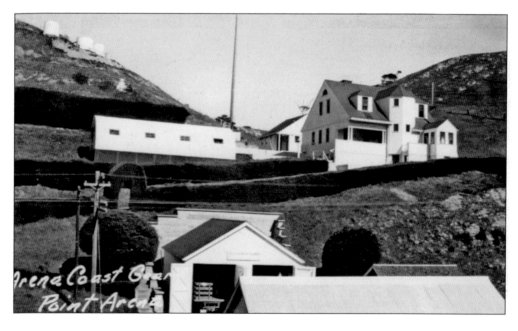

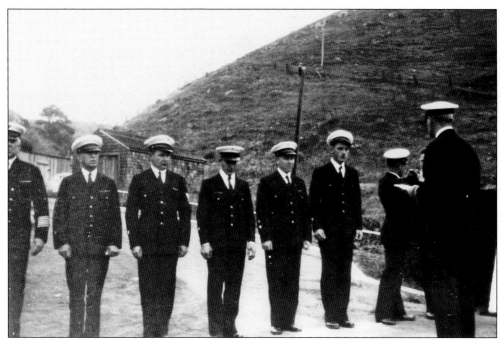

This image shows a 1938 ceremony with an officer speaking to enlisted Coast Guardsmen on the east side of the property originally known as the Life-Saving Station at Arena Cove. The station became the US Coast Guard Life Saving Station after the Coast Guard took over duties of running all Life-Saving Stations in the United States by 1915. (Courtesy Wasserman collection.)

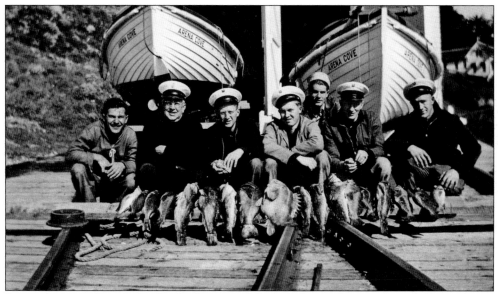

Pictured is a good catch for the day by men of the Life Saving Station. From left to right are unidentified, Marston, Logan, Allison, two unidentified, and Thompson. The men (and fish) are sitting on the ramp and rails, or "on the ways," of the newer boathouse; the two rescue boats are ready to be launched in the event of a rescue at sea. (Courtesy Wasserman collection.)

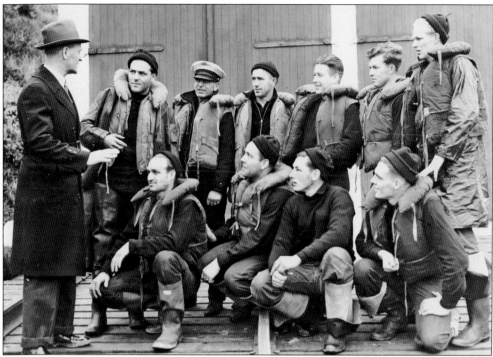

In this late-1940s image, the officer in charge at the station is in the top row, second from the left, and nine surfmen are on the ways of the boathouse at Arena Cove. They are listening to a man, possibly a representative of the 13th District of which the Coast Guard Life Saving Station at Arena Cove was a part. Surfman Leroe Merrit, first row, far left, served at the station for many years. In 1989, he returned for the opening of the Coast Guard House Bed & Breakfast Inn and shared stories of daring rescues. In the bottom image, enlisted men Johnson and Speck are shown atop a mine from World War II that washed ashore near Arena Cove. This photograph was taken on February 15, 1942. By their smiles, the men seem unconcerned about their explosive perch. (Above, courtesy Jack and Sue Gillmore; below, courtesy Wasserman collection.)

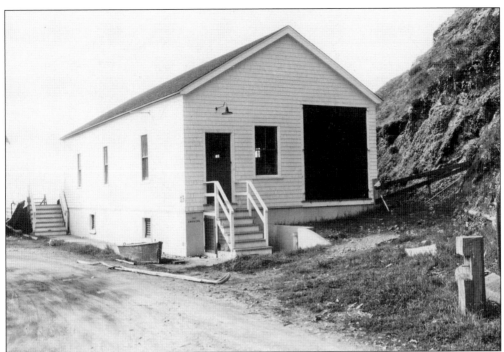

The top image is of the east-side entrance of the boathouse at Arena Cove. The building—measuring 25 feet wide by 60 feet long—was built of fir and redwood with a 12-inch-thick concrete foundation to withstand the high storm seas at the cove. In a comment on the bottom photograph, photographer Nick King, described a favorite pastime for local Arena Cove–watchers: heading down to the water in the winter months to watch the waves "pound hell out of everything!" On January 26, 1983, a rogue wave did just that; the fish-house and the old pier were destroyed, and the boathouse and café sustained serious damage. The big wave picked up tons of rock, blew through the double west-side doors of the boathouse, and carried all the stored tools and equipment out the reinforced east door. Nick King was there to capture this dramatic photograph. (Above, courtesy Wasserman collection; below, courtesy Nicolas King.)

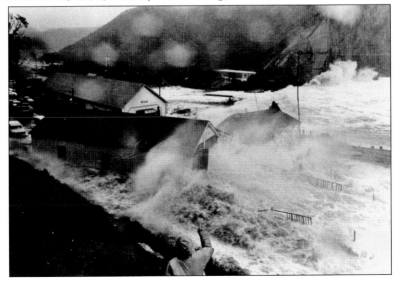

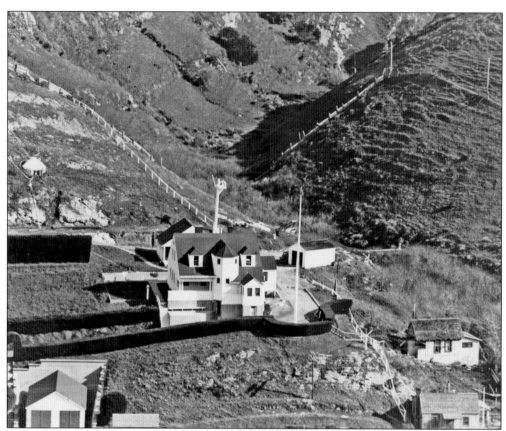

Seen above are the extensive cypress hedgerows and fencing installed at the Life Saving Station after the Coast Guard began operation. The men stationed here were kept busy with installations plus the constant maintenance of keeping hedges immaculately trimmed and wooden and metal surfaces sealed with fresh paint. The tall drill pole (center) for the breeches buoy practice appears to match the height of the flagpole. At upper left, the concrete cistern holds water piped down from a spring up the hill. The original boathouse (lower left) is protected from cliff erosion by massive concrete bulwarks. The uppermost small cottage (lower right) was once home to Capt. William Marsten's wife and daughter Ruth. The cottage below, in the lower right, was home to harbormaster Roy Fox, his wife, Doris, and daughter Dory. In the bottom image, a 1951 Ford owned by the officer in charge is in the garage at the Life Saving Station. (Both, courtesy Wasserman collection.)

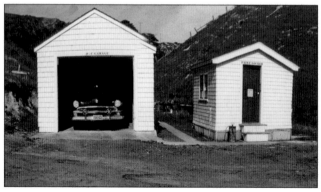

Four

EARTHQUAKE!

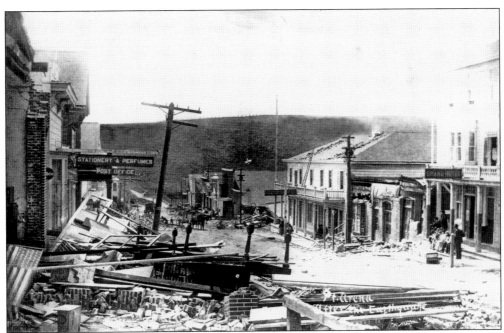

The San Andreas Fault line runs just inland of Point Arena. The area was rocked by earthquakes over the years, but the big quake on April 18, 1906, reduced all the brick buildings in town to rubble and caused extensive damage to the brick tower and keepers' dwelling at Point Arena Light Station, four miles north of town, between Point Arena and Manchester. Photographer William W. Fairbanks's Manchester home was lifted off its foundation. With his camera, he documented much of the destruction along the coast. (Courtesy Steve Oliff.)

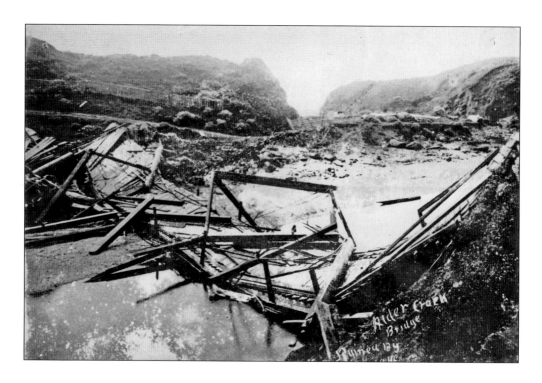

In the top photograph, the San Andreas Fault line goes out to sea at Alder Creek, north of the lighthouse; the bridge at Alder Creek did not stand a chance of surviving the earthquake. In the image below, the fault line ran right through the Fitch property in Manchester, ripping through the barn and moving a row of cypress trees 16 feet out of line. (Both, courtesy Steve Oliff.)

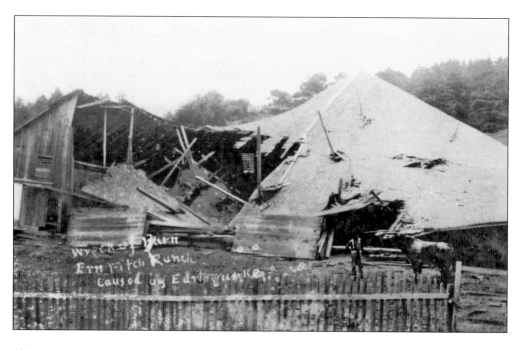

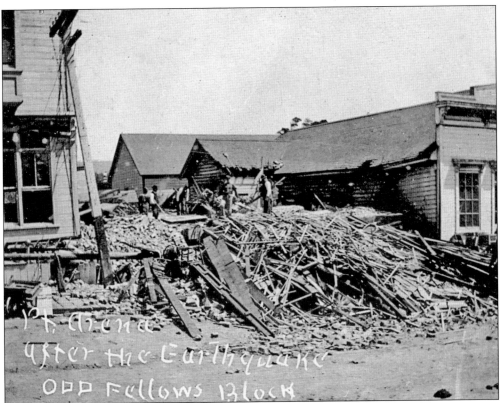

Rebuilding seemed impossible for most Point Arena buildings, like the Odd Fellows Building, pictured above, and the lighthouse, pictured below. In 1911, a traveler named Joseph Smeaton Chase passed through Point Arena. Published in 1913, his diary, titled *California Coast Trails: A Horseback Ride from Mexico to Oregon*, describes his impressions of the small town on the coast: "Put up at the only hotel that remains open for business out of some half dozen whose signs I passed up the street . . . I would not give much for the town's place on the map twenty years hence." Upon viewing the lighthouse, Chase notes, "In the distance, I could see the tall white shaft of the lighthouse, recently built to replace the former one, destroyed by the earthquake of 1906." Though the great quake had not destroyed the tower and dwelling at the station, this was perhaps a more exciting tale than the slow dismantling that actually occurred. (Both, courtesy Steve Oliff.)

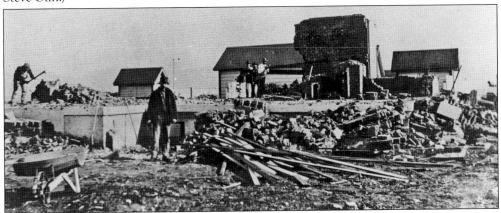

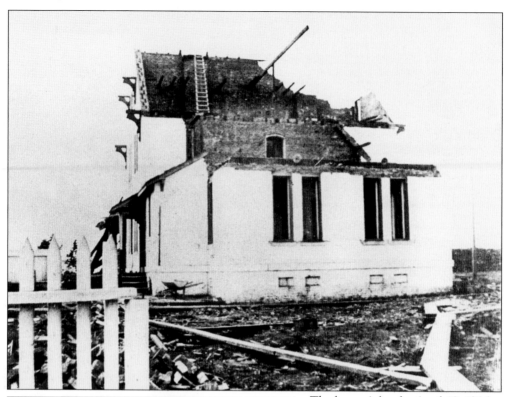

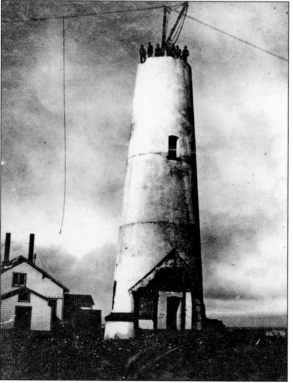

The keeper's log for April 18, 1906, reports, "A heavy blow first struck the tower from the south . . . the tower quivered for a few seconds, went far over to the north, came back, and then swung north again . . . rapid and violent vibrations, rendering the tower apart, the sections grinding and grating upon each other . . . [the lens, reflector and] lantern were shaken from their settings and fell in a shower upon the floor." By November 1906, the dismantling of the two-story keepers' dwelling and tower was well underway. Congress had approved $72,000 to rebuild at the station. (Both, courtesy Steve Oliff.)

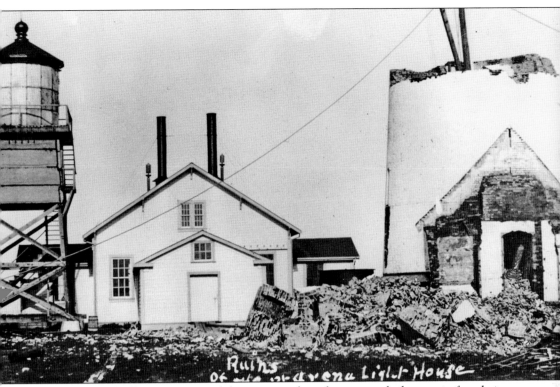

By early 1907, the dwelling was gone and the tower, on the right, was nearly down to its foundation. The fog signal building (center) made of old-growth redwood lumber, withstood the earthquake and continued to operate, guiding mariners carrying relief supplies to San Francisco. The fog whistle system consumed more than 100 cords of wood annually. A temporary tower is seen on the left. Engineers and carpenters from San Francisco, as well as some local laborers, went to work on the dismantling and rebuilding of Station No. 496. (Courtesy Point Arena Lighthouse.)

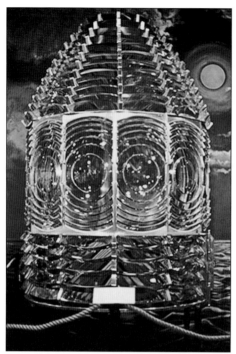

After the earthquake, a borrowed second-order lens (an example is pictured at left) was placed on a 30-foot temporary tower (pictured below) and topped with the lantern room salvaged from the dismantled tower. The light station continued to operate with these two essential aids to navigation until a new tower could be constructed at Point Arena Light Station. (Both, courtesy Point Arena Lighthouse.)

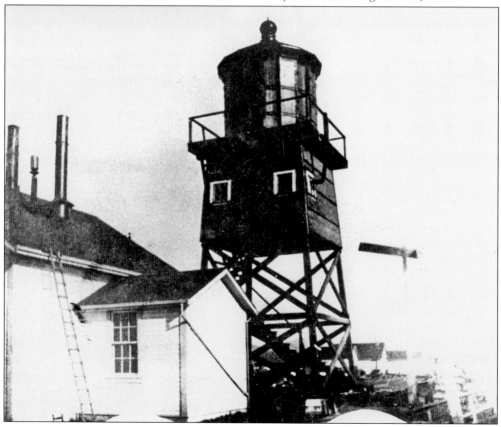

Five

NEW LIGHTHOUSE AND FRESNEL LENS, 1908

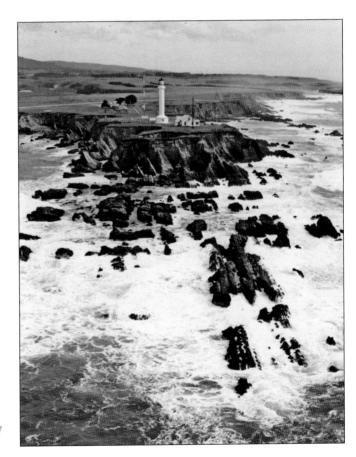

Here is an aerial view of Point Arena Lighthouse, which returned to operation in 1908, showing the 115-foot tower standing firmly on the narrow peninsula that extends approximately one-half mile into the Pacific Ocean. Bartolome Ferrelo, a Spanish explorer, named the point of land Cabo de Fortunas or "Cape of Fortunes." The area would later become known as Punta Arenas or "Point Arena," and in 1869, the US Lighthouse Board laid plans to erect a lighthouse on the 23 acres of plateau atop the sheer 55-foot cliffs. (Courtesy Shirley Zeni.)

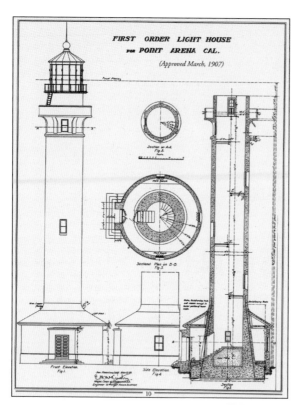

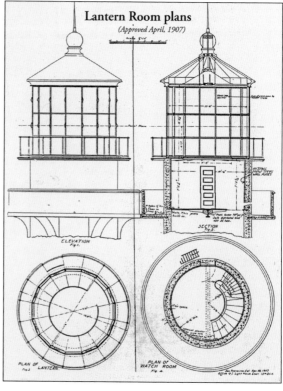

The design of the new lighthouse at Point Arena (pictured left) began with these construction drawings that show the unique feature of the sturdy buttress at the tower's base and the foundation on which the buttress was built. A closer detail of the lantern room shows the staircase leading from the watch room to the lantern room where the new first-order Fresnel lens would be mounted on a pedestal. (Both, courtesy Point Arena Lighthouse.)

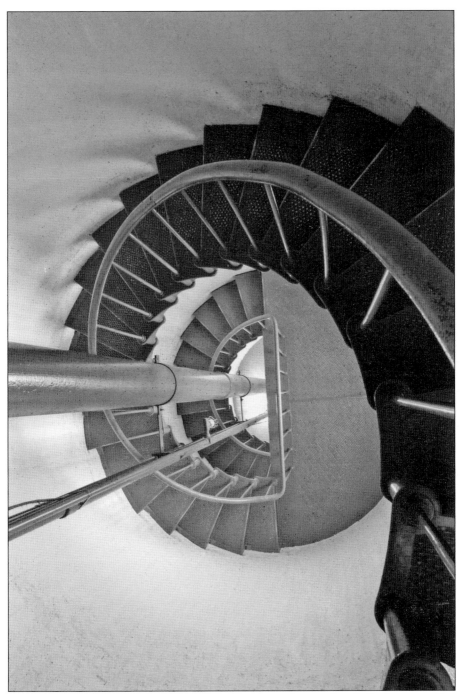

This view looks down the lighthouse steps. Reminiscent of a nautilus shell, the stairwell inside the tower illustrates the beauty of design incorporated in the highly functional light station buildings. The stairs were originally installed in the 1870 tower, and after the earthquake of 1906 they were dismantled for reassembly in the new 1908 tower. It is believed that the sturdy spiral staircase may have kept the original tower from sustaining more extensive damage in the earthquake. (Photograph by Ron Bolander.)

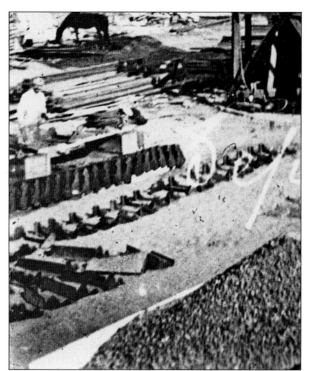

In this photograph from 1907, dismantled parts of the spiral staircase salvaged from the 1870 lighthouse tower lay in organized groupings ready to be cleaned and reconstructed inside the new tower. The mule at the top of the image had the important job of powering the elevator that carried wheelbarrows of concrete to pouring platforms on the scaffolding as the new tower was being built. (Courtesy Shirley Zeni.)

A detailed 1907 drawing of the formworks on plans shows the inside and outside of the new tower. The drawing also shows where the gallery would extend from the outside of the lighthouse. A San Francisco chimney company that normally built smokestacks was selected to rebuild the lighthouse to withstand earthquakes, thus the reinforced concrete method of construction. The tower at Point Arena was the first made with this method. (Courtesy Point Arena Lighthouse.)

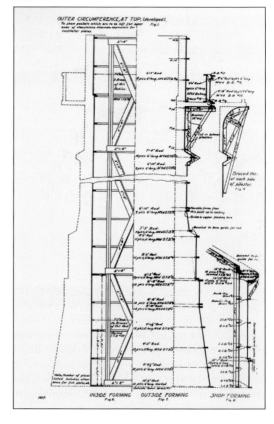

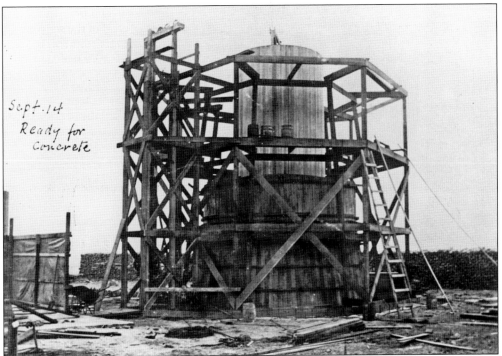

This September 1907 photograph shows the inside and outside formworks of an early phase of the construction of the tower. The foundation was laid in August 1907, and wooden scaffolding was built one section at a time as the tower base and column were constructed. By September, the tower had reached 21 feet. (Courtesy Point Arena Lighthouse.)

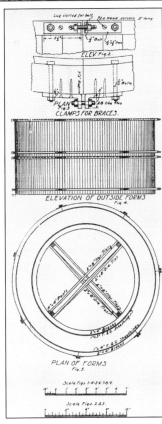

This drawing, titled "Elevation of Outside Forms," illustrates the plans for moveable or slip forms that were used to construct the main body of the concrete tower. The rings banded the forms together and would be tightened before the concrete pour and loosened for release from the hardened or set concrete. The "Plan of Forms" indicates the placement of sturdy posts or ties for reinforcement during the construction of each section of the tower. (Courtesy Point Arena Lighthouse.)

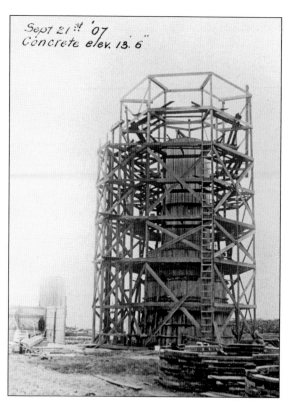

Sept 21st '07
Concrete elev. 13. 6"

By October 2, 1907, the concrete tower reached 42 feet, as seen in the left image. In the photograph below, taken on October 9, 1907, the tower had grown by nearly 20 feet and now measured 60 feet tall. (Both, courtesy Point Arena Lighthouse.)

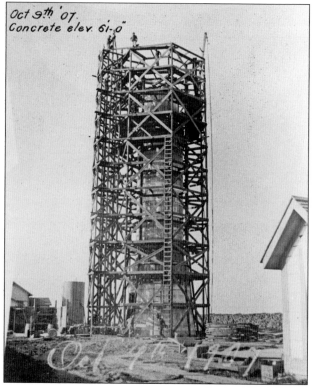

Oct 9th '07.
Concrete elev. 61-0"

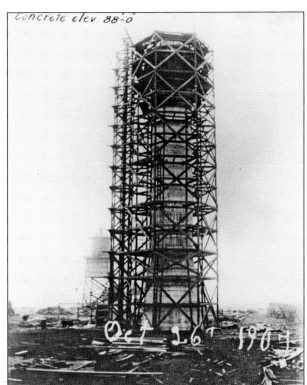

On October 26, 1907, the tower measured 80 feet tall, pictured at right. The temporary tower with a second-order Fresnel lens is clearly visible to the left of the scaffolding. In the bottom image, taken on November 19, 1907, the lantern room peeks from the top of the scaffolding. The newly completed tower now reached its full height of 115 feet. (Both, courtesy Point Arena Lighthouse.)

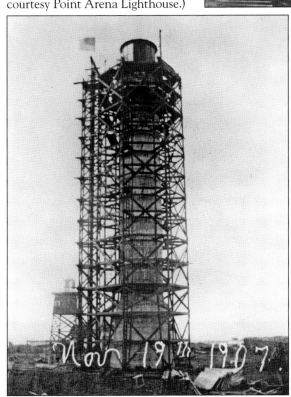

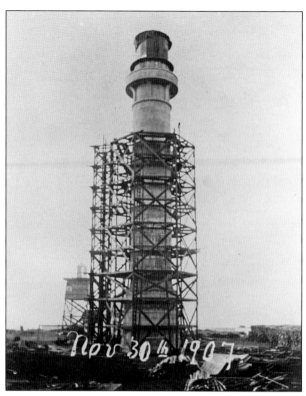

The left image shows that by the end of November 1907, removal of the sturdy scaffolding began, and the top of the new tower was revealed. In the bottom photograph, scaffolding was completely removed by December 14, 1907, and the laborious job of building the buttress soon began. (Both, courtesy Point Arena Lighthouse.)

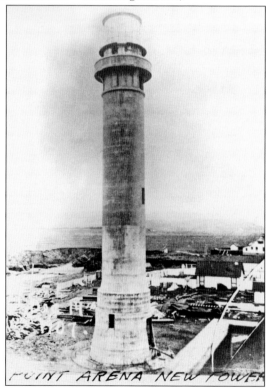

54

Pictured at right in early 1908, the tower is nearly complete but does not have its copper apron protecting the seam at the top of the buttress. The bottom photograph was taken at the time the new tower and keepers' bungalows were completed. In September 1908, the light station was managed by head keeper Richard H. Williams and assistant keepers Charles Below, Oscar Newton, and possibly James Dunn. (Both, courtesy Point Arena Lighthouse.)

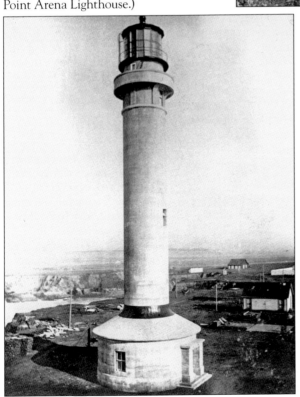

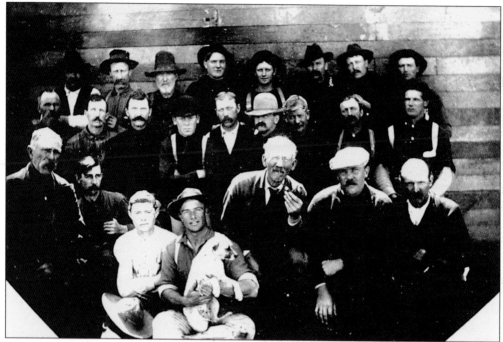

This crew rebuilt the lighthouse during 1907 and 1908, though there were around 30 men who worked on the project. Lighthouse Service engineer George Hooke supervised the project. Walter White supervised the hand-mixing and pouring of an estimated 450 cubic yards of concrete for the tower. Walt Myers supervised the construction by carpenters hired from San Francisco and Point Arena. Four employees of the Lighthouse Service were transferred to Point Arena to supervise various aspects of the reconstruction, and it is likely that they are among the older men in the front row of the photograph. Interestingly, the two young men, one holding a dog, seem to have been added somehow to the image as they appear in a very different light than the rest of the crew. (Courtesy Point Arena Lighthouse.)

Dated 1935, this photograph shows two lighthouse keepers wearing work overalls. This attire was worn while cleaning the lens and brass work and handling fuel for the lamp. A few lines in a 1913 copy of the *Point Arena Record* announced "Point Arena Lighthouse was given the star by the U.S. Lighthouse Service." The Efficiency Star was awarded after inspectors gave an excellent report for the station during three previous inspections. (Courtesy Joyce Pratt.)

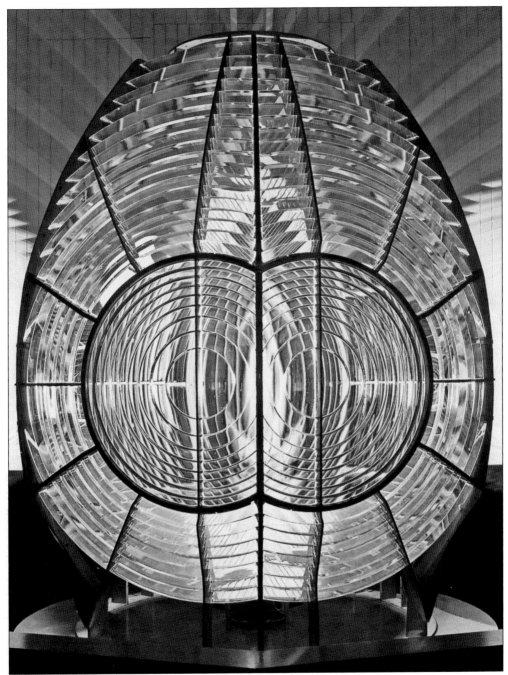

On July 10, 1908, the *Point Arena Record* reported, "Milo Hoadley and C. A. Dunn arrived to install the lens in the new lighthouse." In this 2008 photograph, the first-order Fresnel lens is shown on display in the lighthouse museum, where it is well protected in its new home. The rare lens is designed with three double bull's-eyes. The lens beamed the light 20 miles out to sea. The signature of the lens was a double white flash every six seconds. Just as assistant keepers did in the past, the Coast Guard Auxiliary currently performs a regular cleaning and polishing of all 666 hand-ground prism sections of the treasured lens. (Photograph by Ron Bolander.)

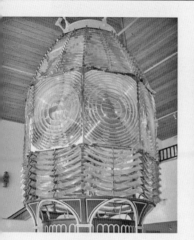

**FRESNEL LENSES OF VARIOUS ORDERS
TO A COMMON SCALE**

1st 2nd 3rd 4th 5th 6t

This image displays a series of Fresnel lenses, from first order (far left) to sixth order (far right). The orders were originally standardized based on the number of concentric cylindrical wicks in the lamp used in each order or size. A first-order Fresnel lens, weighing 4,700 pounds, was placed in the lantern room of the new tower at Point Arena. A fully assembled lens with platen and mercury float bearing weighs between 11,000 and 13,000 pounds. Originally, a first-order lens would have used a four-wick lamp or lantern. From 1908 to 1928, the Point Arena lens was illuminated with an incandescent oil vapor lamp. The mercury float bearing supporting the lens required approximately 5.3 gallons of mercury. The rotation of the lens was driven by clockwork, its speed managed by a governor. A 160-pound weight raised to the watch room would lower to the bottom of the tower every 75 minutes. (Courtesy Point Arena Lighthouse.)

In this photograph from August 29, 1926, the tower shows its new daymark of a black band, made of copper, at the top of the buttress and black exterior gallery and watch room walls. It was several years after construction before the tower was painted. (Courtesy Shirley Zeni.)

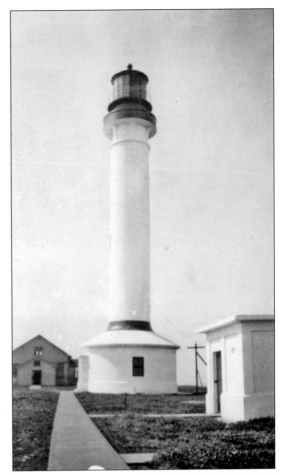

After the earthquake, four well-built bungalows were erected at the station to accommodate the lighthouse keepers and their families. They were all especially happy to have private homes to replace the original four-plex. It was difficult for four families to live comfortably and for keepers to rest with so many folks living under one roof. (Courtesy Shirley Zeni.)

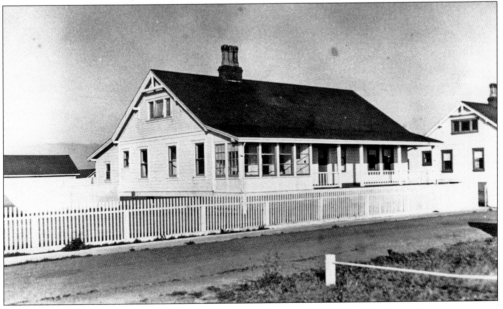

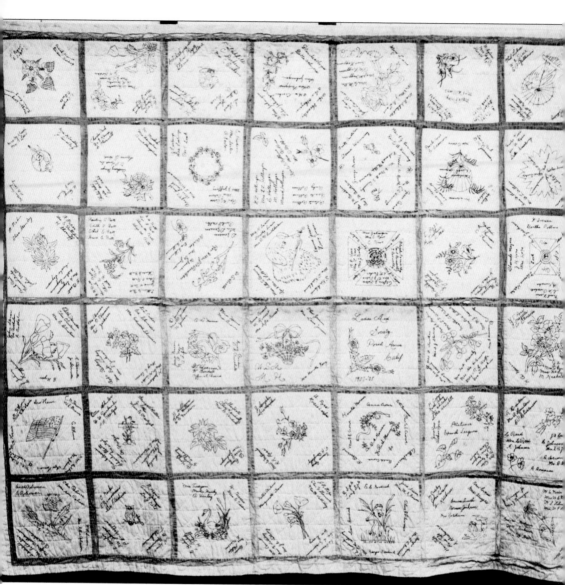

During 1907 and 1908, the Point Arena Lighthouse quilt was sewn by members of the Ladies Aid Society of Point Arena. Considered a "friendship quilt," the rare textile is embroidered in "red work" style and incorporates nursery characters, baskets, birds, and flowers, typical for quilt blocks of this time. The leading force behind the creation of the quilt was Lydia Howell, who was married to Newton Howell, the Point Arena blacksmith and district supervisor. The names of all local citizens who contributed to the quilt are embroidered on it. With 42 blocks, the list of names is a veritable who's who of the Mendocino coast and especially of Point Arena. The precious quilt is now displayed in a prominent location in the lighthouse museum. (Photograph by Nicolas Epanchin; courtesy Point Arena Lighthouse.)

This block, decorated with flowers, is beautifully stitched with the words, "Ladies Aid Society Point Arena, Calif. 1907–'08." It is at the center of the quilt that was presented to the head keeper and family in September 1908 to commemorate the reopening of the light station after the earthquake of 1906. (Photograph by Nicolas Epanchin; courtesy Point Arena Lighthouse.)

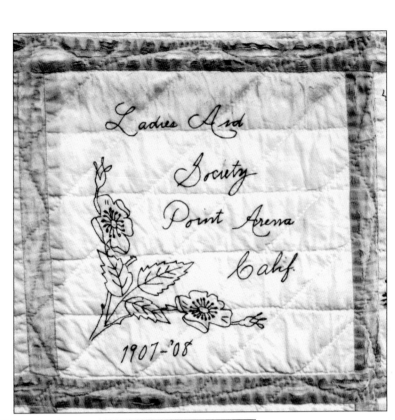

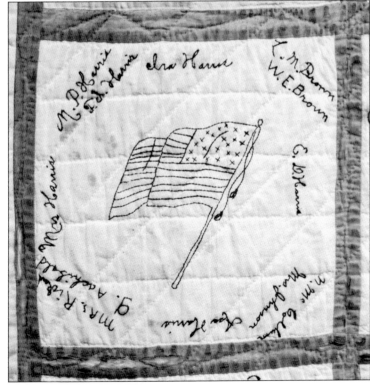

The flag embroidered on this block is reminiscent of the big, annual Fourth of July celebration in the little town of Point Arena. (Photograph by Nicolas Epanchin; courtesy Point Arena Lighthouse.)

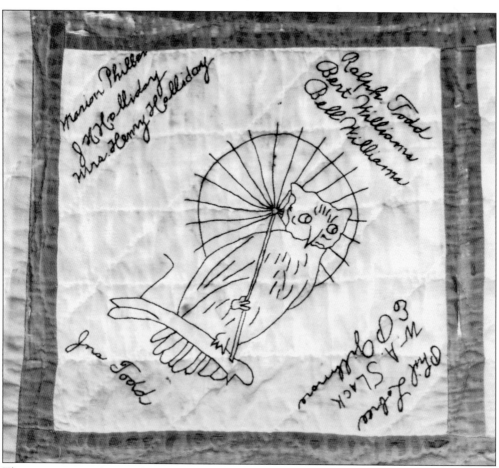

These two images show a whimsical owl holding a parasol (above) and a detail of the central area of the quilt (below). The Point Arena Lighthouse quilt was created in commemoration of the opening of the new tower in September 1908, after the devastating earthquake in April 1906. The quilt was passed down through generations of women in the Howell family. Francis Heins, granddaughter of Lydia Howell, finally donated the quilt to the lighthouse during the time that Bill Owens was head keeper at the station. (Photograph by Nicolas Epanchin; courtesy Point Arena Lighthouse.)

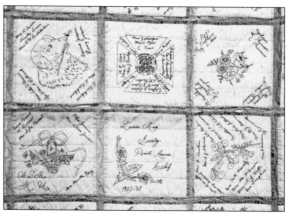

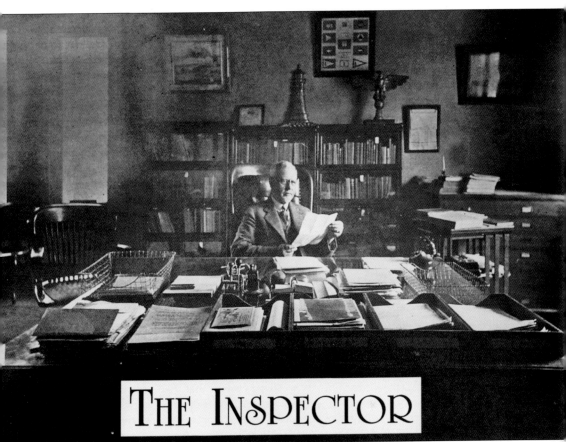

THE INSPECTOR

Lighthouse inspector Capt. William Rhodes represented the 12th District for the Lighthouse Service. He would travel by ship, called a lighthouse tender, to the lighthouses in the district. In her memoirs *Lighthouse Memories*, Isabel Owens, wife of keeper Bill Owens, recalled, "The brass must be polished once a week. The men had the engine room, the watch room, light tower and workshop. They had lots of brass to polish and floors to wax . . . in the houses we had brass lamps, a dust pan, a lamp filler and door knobs. The government furnished the wax and polish. . . . The kitchen stove was last." When Captain Rhodes was expected, the station would receive a couple of days notice. He would come wearing white gloves and rub his hands over the walls and door frames. Because of his goatee, he soon earned the nickname of "Billy Goat Rhodes." (Courtesy Point Arena Lighthouse.)

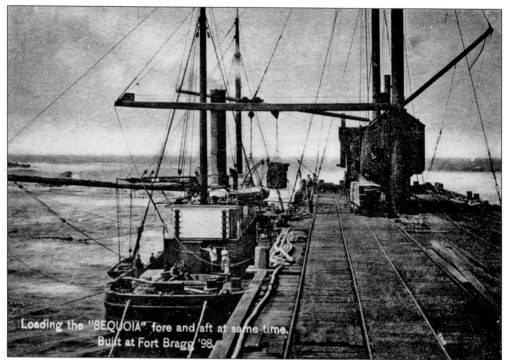

Loading the "SEQUOIA" fore and aft at same time.
Built at Fort Bragg '98.

The *Sequoia* was a lighthouse tender that regularly brought supplies to Arena Cove for the lighthouse keepers. It also delivered the inspectors who would spend the day performing their duty at the light station and preparing the report for the district office, where it would enter into a permanent record of how well the station was being run. Some inspectors were more understanding than others; generally, the keepers and wives did not look forward to the arrival of the inspectors nearly as much as the delivery of necessary supplies and food for the station. (Above, courtesy Wasserman collection; below, courtesy Bruce Rogerson.)

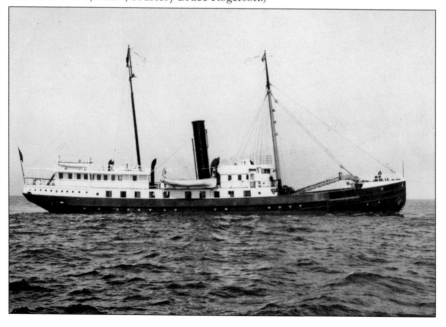

Six

THE MIDDLE YEARS, 1920–1945

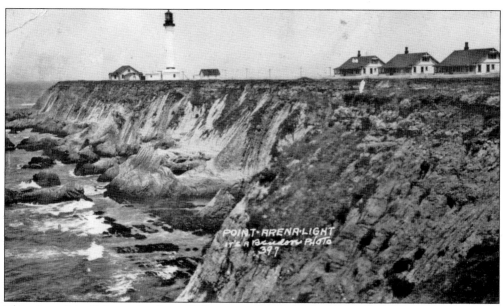

This view of the light station from 1927 appears almost pastoral; even the ocean waves appear to lap gently. It was a relatively quiet time at the lighthouse and at Arena Cove. The lumber trade and ocean transport had slowed. The lumber chute at the cove was discontinued in 1912 after the mill stopped operating at Flumeville, two miles east of the lighthouse. (Courtesy Shirley Zeni.)

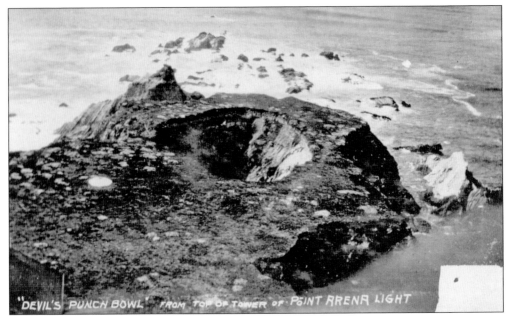

Here is a view from the top, taken from the gallery outside the watch room looking down on Devil's Punchbowl, the sinkhole that forms the western tip of the peninsula. Point Arena Light Station stretches out across 23 acres on the rocky bluff. Devil's Punchbowl, once a small hole, was enlarged over time by rough weather and many surging tides. (Courtesy Point Arena Lighthouse.)

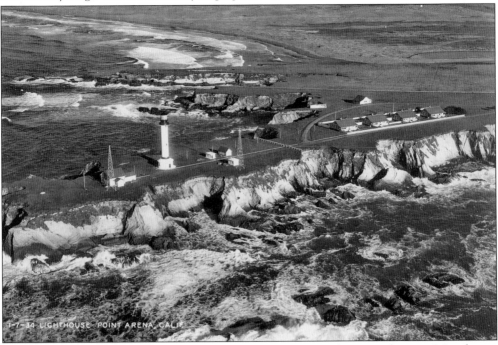

In this aerial view of the light station, the entire 23 acres can be seen adjoining Manchester State Beach on the north. The San Andreas Fault runs somewhat north and south along the lighter shade at the top of the photograph. No signage marks the fault line. (Courtesy Point Arena Lighthouse.)

This cistern is located south of the keepers' houses. A windmill near this site was used to pump water from a well. This system supplied fresh water for the houses. (Courtesy Shirley Zeni.)

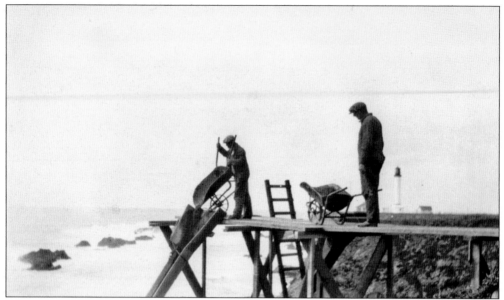

In this image from the late 1920s, two men are pouring something from wheelbarrows down a chute built into the cliff south of the keepers' houses. They are possibly pouring materials for the concrete interior of the cistern in the image on the previous page. (Courtesy Joyce Pratt.)

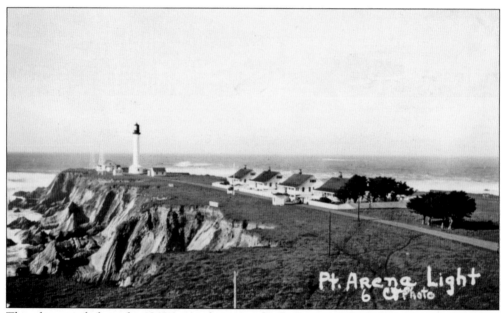

This photograph from the 1940s was taken near the front gate at the light station. It shows the graceful lay of the land before the bluff became covered with wildflowers and plants that now create an uneven terrain that blooms each spring and summer into pinks, yellows, reds, blues, and purples. Among the wildflowers and native plants are seaside daisy, seaside golden yarrow, miniature lupine, beach strawberry, California sea pink, California poppy, little owl's clover, Douglas iris, hooded ladies tresses, baby blue eyes, and pussy ears. (Courtesy Shirley Zeni.)

Many of the Point Arena buildings seen in this photograph, taken on February 28, 1927, burned down in the fire of July 1927. The fire started in a third-story room in the Grand Hotel on Main Street. The town was cut off from communication by fire-damaged telephone lines, and water from the gravity water system was in short supply. (Courtesy Shirley Zeni.)

Looking east on Main Street, from left to right, the town hall, firehouse, and Presbyterian church are as they appeared in 1927. As in the previous photograph, all of these buildings were destroyed by fire in July 1927. (Courtesy Shirley Zeni.)

In this photograph taken on February 28, 1927, Ralph McMillen and Point Arena fire chief Harry Brunges are shown in the first ladder truck owned by the fire department. In a town that was taken down by fires in 1893, 1927, and 1945 and rebuilt a number of times, the hook and ladder company held great importance for the townspeople. (Courtesy Shirley Zeni.)

In a family album carefully inscribed by Sadie Garcia before her marriage to Ralph McMillen, a notation points to the upper-story room on the right as "Sadie's Room." In 1906, the Point Arena Hotel temporarily housed four engineers brought to Point Arena by the Lighthouse Service to build the new tower at Point Arena Lighthouse. (Courtesy Shirley Zeni.)

Taken in 1926, the top image is titled "Point Arena Police Squad" by Sadie Garcia, pictured at the far right. All others in the "Police Squad" are unidentified. In the right photograph from 1927, the real Point Arena jail, which was also known as "the Calaboose," was located at the foot of Main Street. The building was razed in 1964 by Reed Farnsworth to make room for an addition to the Point Arena Motor Court. (Both, courtesy Shirley Zeni.)

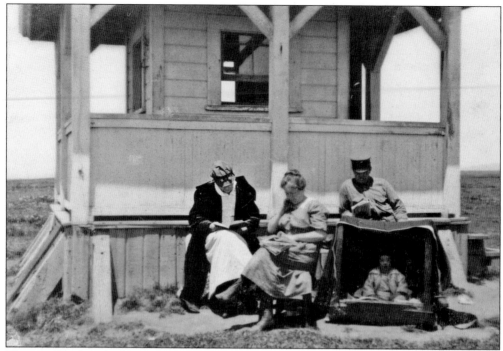

This small lookout building was constructed on the north bluff above Arena Cove as part of the Life-Saving Station operation. A family group visits and probably delivers a meal to the man on watch duty. (Courtesy Shirley Zeni.)

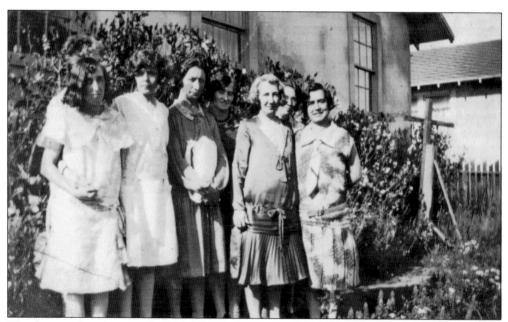

The date on this photograph is August 15, 1930, and it is titled "The Bridge Club." The image was taken in Point Arena, and the only identified person is Sadie McMillen, at far right. One could feel pretty isolated living in Point Arena, making clubs like this one very popular. (Courtesy Shirley Zeni.)

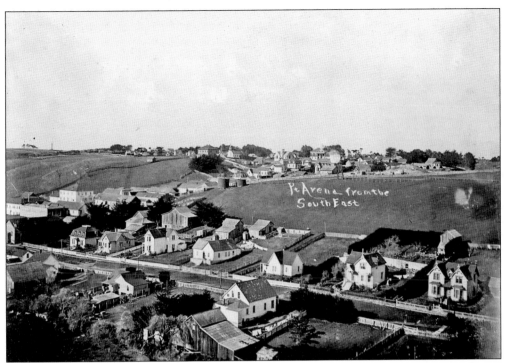

Pictured here is Mill Street, Point Arena, in the early 1900s. Many of the prosperous families in Point Arena built homes on Mill Street. Well-known families of the town—the Hallidays, Hietts, Haskels, McCallums, Mazzettas, and later the McMillens, Gillmores, and Disotelles—lived on Mill Street. City lights finally came to Point Arena in 1905; however, there were many ups and downs over the first several years for the Electric Light Company. When this photograph of the Point Arena power plant was taken in 1927, things seemed to be running smoothly, however, the *Point Arena Record* reported in January 1931 that the "Power plant breaks down, Our town was in darkness a couple of nights this week." (Both, courtesy Steve Oliff.)

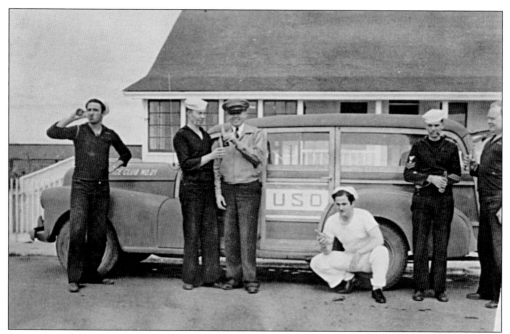

Service Club No. 21 of the United Service Organization (USO), a nonprofit organization since 1941, came to the edge of the North American continent in the early 1940s to entertain the officers and enlisted men stationed at the Coast Guard Long Range Navigation (LORAN) station, the Life Saving Station, and the lighthouse at Point Arena. Bill and Isabel Owens's daughters fondly remember the shows. (Courtesy Owens family collection.)

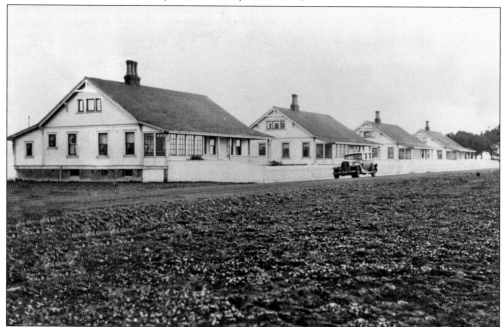

This photograph from the mid-1920s is captioned in Sadie Garcia's album, "Laura Williams' house." Laura Williams was likely the wife of Elmer R. Williams, who was assistant keeper at the lighthouse from 1925 to 1935, then he became head keeper from 1935 to 1940. (Courtesy Shirley Zeni.)

In the photograph above, taken in the 1960s at Point Arena Light Station, the photographer captured the beacon shining out from the lantern room and fog signal buildings with foghorn apparatus behind. In the 1960s image to the right, the complex piping and generator system that ran the foghorns is seen inside the fog signal building. (Both, courtesy Owens family collection.)

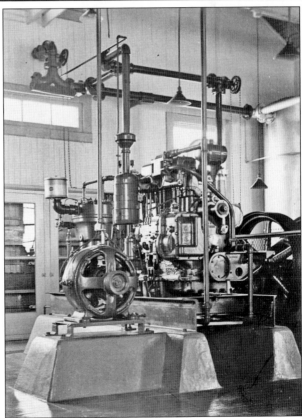

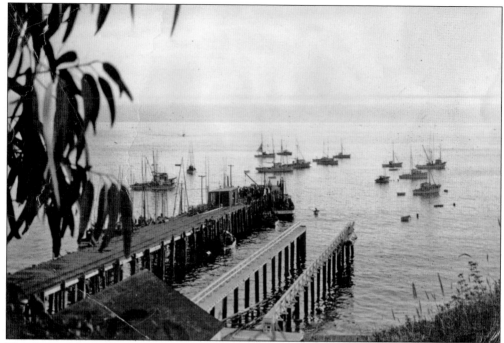

The dates of these photographs are unknown. The top one was taken from the steep hillside on the north side of Arena Cove looking west toward the old pier and the ramp used by the Life-Saving Service and eventually the Coast Guard to launch lifeboats at the cove. The lower image was taken on a calm day from the north bluff above Arena Cove. In 1983, when a rogue wave knocked the remaining planks off the old pier, critics swore that would be the end of fishing commerce for the city of Point Arena. Defying the odds, in 1986, the city received grant funding to rebuild the pier. Once again, the cove became a thriving asset for the city; today, it remains an integral part of the city's economy. (Both, courtesy Shirley Zeni.)

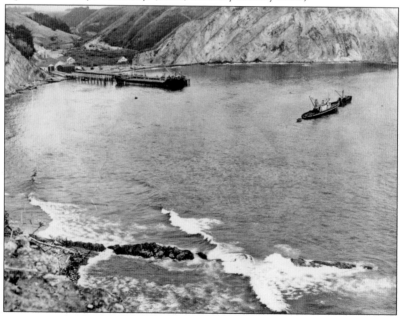

Seven

LIGHTHOUSE KEEPERS AND FAMILIES

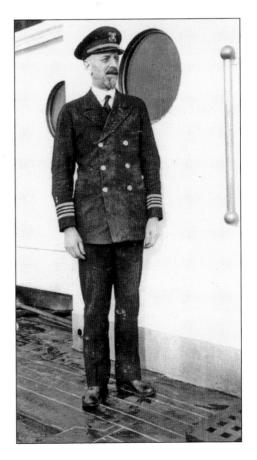

Capt. J.W. Leadbetter was born in Vindalhaven, Maine, in 1878. He joined the Lighthouse Service in 1912 and supervised the building of the steel-hulled lighthouse tender _Cedar_ in 1915. The _Cedar_ was 90 feet long and the largest tender built for the service. Leadbetter was her first skipper and commander for 23 years. In 1939, both the _Cedar_ and Captain Leadbetter transferred to the US Coast Guard when the Lighthouse Service was incorporated into the Coast Guard. Captain Leadbetter guided the _Cedar_ into isolated ports in the North Pacific, supplying lighthouses along the coast. He very likely landed the _Cedar_ at Arena Cove to leave supplies for Point Arena Lighthouse. (Courtesy Point Arena Lighthouse.)

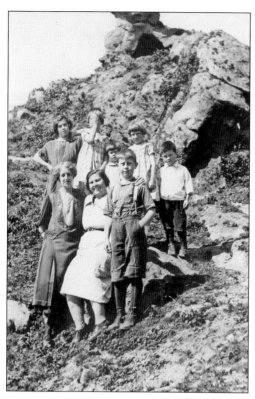

Pictured here are Kane family members with Agnes Kane (first row, center). Keeper Winfred R. Kane came to the Point Arena Light Station as an assistant keeper in 1913. On April 29, 1926, he was promoted to head keeper and served in that position until June 14, 1934. (Courtesy Point Arena Lighthouse.)

In this photograph from 1904, keepers and their families enjoy a time of relaxation. Pictured from left to right are unidentified, assistant keeper William Lewis Austin, Martha Maria Austin holding infant Perry Austin (born 1903), possibly head keeper Richard H. Williams, and unidentified. Thelma Austin, in front, was born in 1901. Assistant keeper Will Austin served at Point Arena Lighthouse from November 1904 until July 1906. Martha McKinzie, president of Point Fermin Lighthouse Society, is the granddaughter of Will and Martha Austin. (Courtesy Martha McKinzie.)

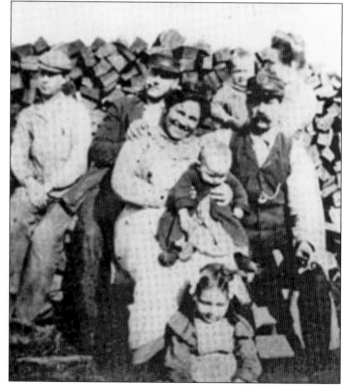

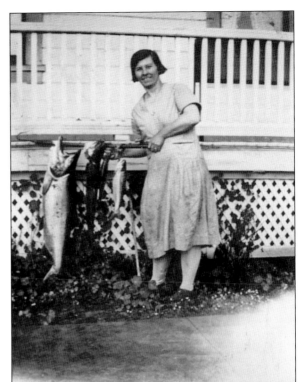

Agnes Kane, wife of head keeper Winfred R. Kane, exhibits some hefty salmon. Lighthouse families enjoyed delicious meals of salmon, mussels, venison, and game fowl and any vegetables from their gardens that the gophers did not eat. Keeper Bill Owens's wife, Isabel, got so fed up with the number of gophers at the station that she began to shoot them on sight. (Both, courtesy Point Arena Lighthouse.)

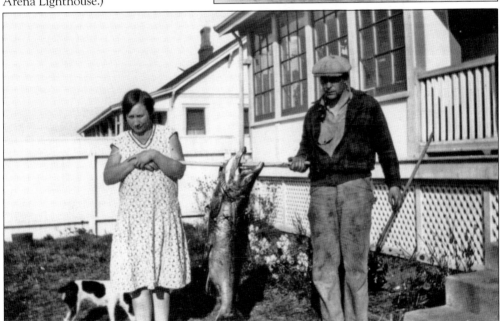

Mars and Della Kenyon are pictured in 1930 with Fritz the dog and a large Chinook salmon. Kenyon was a keeper from possibly Row Island Lighthouse, near the naval station at Port Chicago. He was a friend of Point Arena Lighthouse assistant keeper Lovel J. Hamilton. The nearby Garcia River offered excellent fishing; many keepers from the lighthouse enjoyed fishing as a break from the daily routine at the station. (Courtesy Joyce Pratt.)

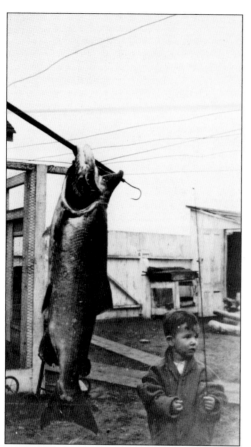

Harry Hamilton poses here with a very large Chinook salmon. Harry is the son of assistant keeper L.J. Hamilton. This photograph was taken in 1930 in the backyard of the family's home at the station. The chicken coop on left was used for a time to keep quail after assistant keeper Hamilton found four eggs and raised the birds, as daughter Joyce Hamilton Pratt remembers. In this photograph, clotheslines run overhead—there was always plenty of wind at the lighthouse. (Courtesy Joyce Pratt.)

Harry Hamilton (left), born in 1928, and Joyce Hamilton (right), born 1930, are in front of their home at the station. Harry appears to be a little unhappy on the tricycle while his baby sister Joyce gets to try out the sporty car. Joyce was born at Point Arena Light Station. The doctor was "Old Doc" Huntley, a country doctor who lived in the area for many years and surely delivered many babies during his practice. (Courtesy Joyce Pratt.)

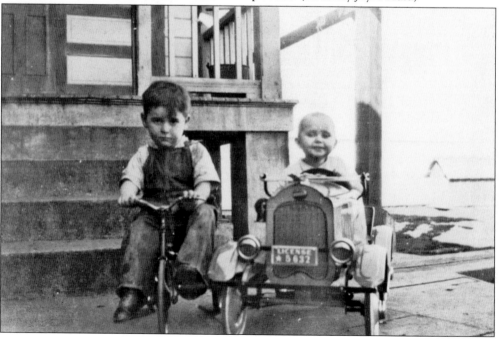

The two youngest Hamilton children have a view of the top of the lighthouse while playing in the front yard where the side fence was solid wood. One of their mother's greatest fears was that the children would fall over the edge of the 50-foot cliffs. One day, Harry was missing and a search was underway when, to his mother Helen's relief, he was discovered under the house asleep in a box with his dog Skippy. (Courtesy Joyce Pratt.)

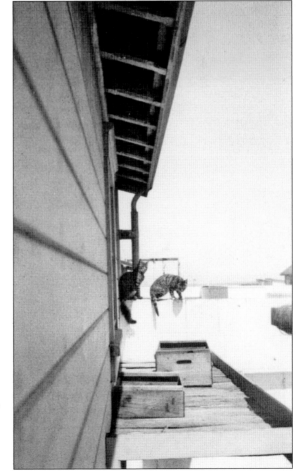

Lighthouse cats Fluffy and Tuffy belonged to Joyce and Harry Hamilton. Joyce recalls that Tuffy lived an especially long life, eventually going to live with Harry and Joyce Hamilton's older sister, Arline, when the Hamilton family moved from the light station. (Courtesy Joyce Pratt.)

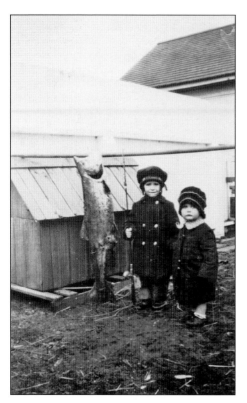

Bundled against the cold wind at the lighthouse, Harry and Joyce Hamilton stand by yet another large salmon. Joyce remembers, "We ate a lot of salmon!" Other tasty treats were found in the shops of Point Arena. Joyce fondly recalls going to town with her mother and visiting Ralph "Happy" McMillen's store. "Happy" gave folks a big box of cookies when they paid their account bill, and the butcher often gave Joyce a hot dog when her mother purchased meat. Joyce was in the same grade in school with Jack Gillmore, whose parents owned Gillmore's General Merchandise in Point Arena. (Courtesy Joyce Pratt.)

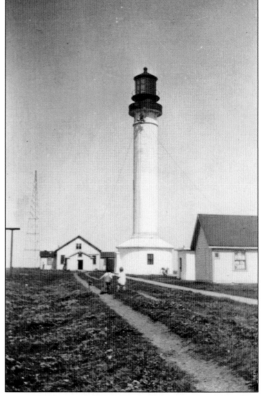

Whitewashing the tower in 1933, first assistant keeper Elmer R. Williams is lowered from the gallery in a barrel to get the job done. Bill Owens moved to the station in the late 1930s and, being of slight stature, he was the keeper sent round the tower in the barrel. In this image, young Harry Hamilton holds out his hand to warn his sister Joyce to stay back from the tower as the children had been cautioned when the tower was being whitewashed. (Courtesy Joyce Pratt.)

The Hamilton family poses. From left to right are (first row) Harry and Joyce; (second row) Helen Hamilton, assistant keeper L.J. Hamilton, and eldest daughter Arline. The family is on their front porch near a side door that led to the sunroom of their home at the station. Joyce remembers that the family spent much of their time in the large, warm kitchen. It was a good place to sit and do homework while her mother, Helen, made bread. She also remembers her father, L.J., enjoying quiet moments sitting by the fire in the dining room. Often called "L.J." for Lovel Joyce, he was teased as a kid and called "Spider Kelly" because of his fear of spiders. Of course, he preferred being called just "L.J." (Courtesy Joyce Pratt.)

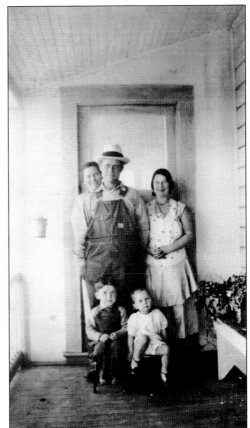

Arline Hamilton is near the front steps of the Hamiltons' house at the station. "The whole family would play hide and seek in the house at night or read or play other games like Parcheesi and Whist," recalls Joyce Hamilton Pratt. It must have been fun to have an older sister, though Arline married at age 17 and started a home of her own in Point Arena. (Courtesy Joyce Pratt.)

In 1934, when Arline Hamilton married George McMillen, three founding families of Point Arena were joined through the union: the Hamiltons, Hunters, and McMillens. Pictured on the front steps of the Hamilton home are, from left to right, (first row) Joyce and Harry Hamilton; (second row) Clara Hunter (Helen Hamilton's sister), Arline Hamilton McMillen, George W. McMillen, and Jimmy Christensen; (third row) Eva Hunter (Helen's mother), Lovel J. Hamilton, Helen Hamilton, and unidentified; (fourth row) a man who is believed to be the minister who officiated the ceremony, and two unidentified. (Courtesy William Kramer.)

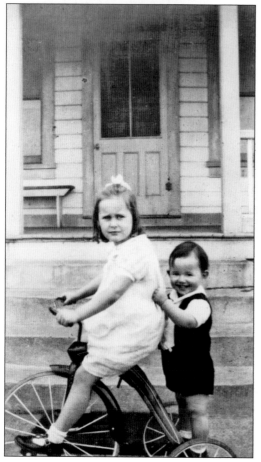

In 1935, Arline and George McMillen had a son named William, or "Billy" as he was called. Joyce Hamilton, age 6, and Billy, age 13 months, are pictured. The three children spent much of their childhood years together, and Joyce, who was actually Billy's aunt, commented that Billy felt like a brother to her. Joyce and Billy were both born at the lighthouse at the Hamilton home; the attending doctor was "Old Doc" Huntley. (Courtesy Joyce Pratt.)

Harry Hamilton, age seven and a half, and Billy McMillen are pictured here. Old Doc Huntley had a son who also became a doctor. He was known as "Young Doc" Huntley and did not live in the Point Arena area again until after his retirement. "Young Doc" had a daughter who became a dermatologist; she was called "Skinny Doc." (Courtesy Joyce Pratt.)

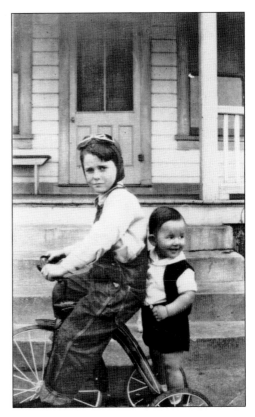

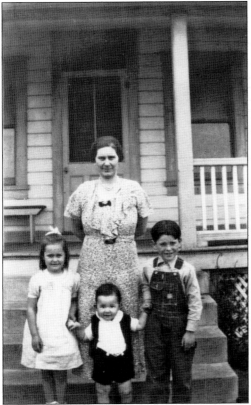

In front are, from left to right, Joyce Hamilton, Billy McMillen, and Harry Hamilton, with Helen Hamilton behind. Billy's mother, Arline, moved to her grandmother's ranch, called Hunter Ranch, after her marriage to George McMillen. Helen Hamilton and her husband, assistant keeper L.J. Hamilton, were born in Point Arena, as were their parents. Joyce recalls that her grandfathers were referred to as "Old Man" Hunter and "Old Man" Hamilton; the two were founding fathers of Point Arena. (Courtesy Joyce Pratt.)

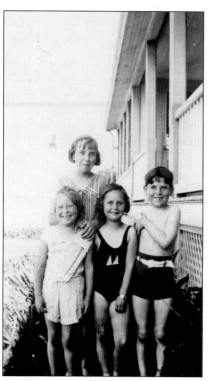

Pictured here in 1936, from left to right, are Delores Titus, Shirley Titus, Joyce Hamilton, and Harry Hamilton with the lighthouse tower in the background. The Titus girls' father was Lilburn Titus, a relative of assistant keeper Hamilton. From 1937 to 1941, Lilburn Titus served as an assistant keeper at the station. It was unusual to see anyone wearing a bathing suit at the lighthouse! (Courtesy Joyce Pratt.)

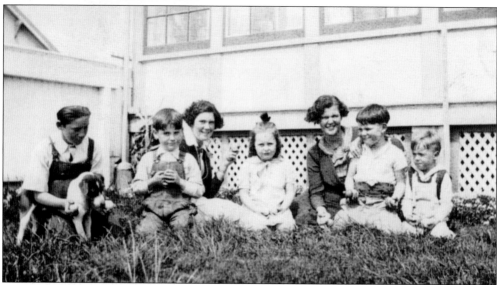

This photograph was taken in 1936 on the lawn behind a keeper's home. From left to right are Arnold Heard with Harry's dog Fritz, Harry Hamilton, Dolly Belle Heard, Joyce Hamilton, Margaret Heard, Clifford Heard, and Donald Hall. Each child is holding an Easter egg. A.G. Heard was an assistant keeper until he left Point Arena Light Station in 1937. Joyce Hamilton recalls that she and brother Harry were not restricted from going up in the tower with their father, L.J., when he took visitors to the top. They would often wait under the stairs near the bottom of the tower and grab visitors' feet as they descended. "Just a gentle grab," promised Joyce. (Courtesy Joyce Pratt.)

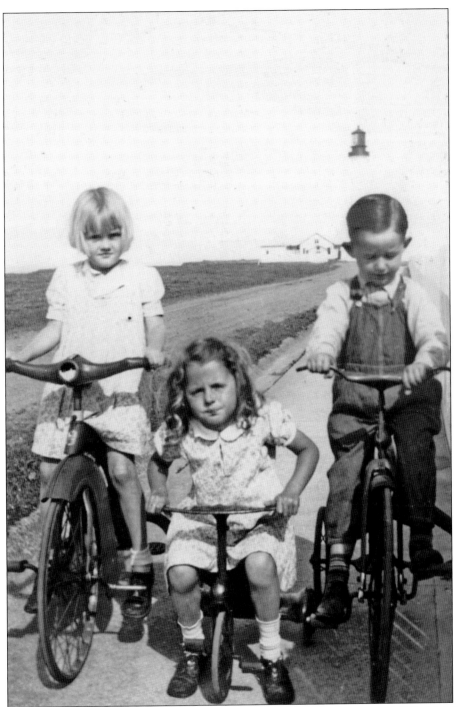

Seen in this 1938 image are, from left to right, Joan Owens, Jean Owens, and Billy McMillen on tricycles in front of the keepers' houses with the lighthouse tower in the background. At the time of this photograph, the station had 13 children of all ages who enjoyed playing together, especially with the property being four miles from town where their other friends lived. (Courtesy William "Bill" Kramer.)

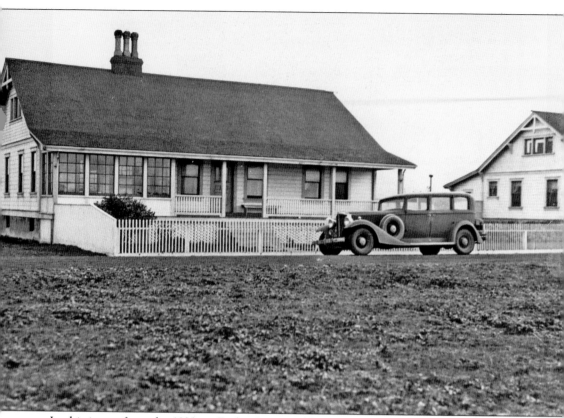

In this image from the 1930s, a Packard or possibly a Rickenbacker car is parked in front of a keeper's home on the west end of the row of four bungalows. The car originally belonged to the Hamilton family. In the summer of 1937, Bill Owens became an assistant keeper at Point Arena Light Station. He moved his wife and five daughters into this house and eventually purchased the car from assistant keeper L.J. Hamilton. Both keepers used the car to transport their children and a number of others to school in Point Arena. (Courtesy Owens family collection.)

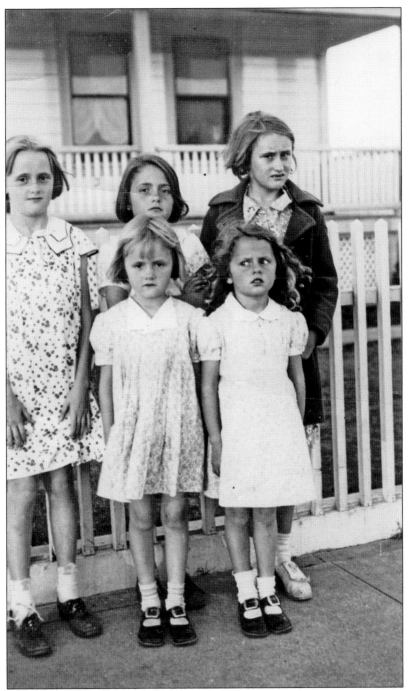

In 1941, five of the Owens girls pose in spring dresses. From left to right are (first row) twins Joan and Jean; (second row) Sarah, Dixie, and Shirley. Bill and Isabel Owens met and married in Maryland in 1922. Isabel Owens was born a farm girl but was raised in Baltimore, Maryland. Attracted by milder climate, they moved to San Francisco in 1926. Bill loved to fish. While fishing on Angel Island in San Francisco Bay, he met the lighthouse keeper there and decided being a light keeper would be the life for him. (Courtesy Owens family collection.)

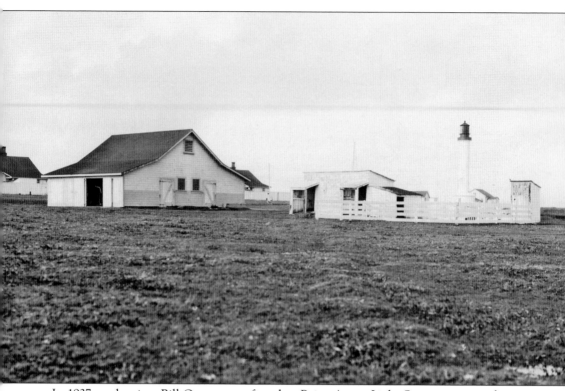

In 1937, at the time Bill Owens transferred to Point Arena Light Station as second assistant keeper, Elmer R. Williams was head keeper. Later, Bill Owens was promoted to head keeper. It was a good life at the well-equipped station, with a roomy, comfortable home, fenced yard with a vegetable garden in the back, a chicken coop, a large garage (on the left), a barn (center) for Bessie the cow, and good neighbors with children for the Owens girls to play with. (Courtesy Owens family collection.)

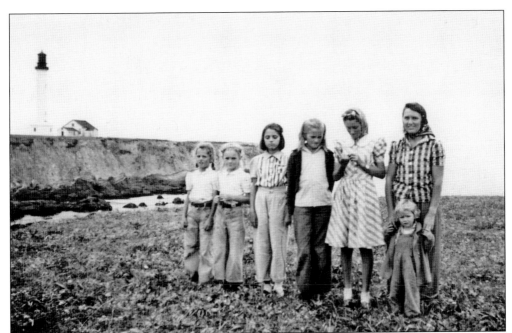

This photograph was taken in 1942 on the headland looking south toward the lighthouse and fog signal building. Pictured from left to right are Owens girls Jean, Joan, Dixie, Sarah, and Shirley. Diana, the youngest, is standing in front of Isabel Owens. Note that trousers had become acceptable attire for girls and women—necessary protection from the chilly winds at the station. (Courtesy Owens family collection.)

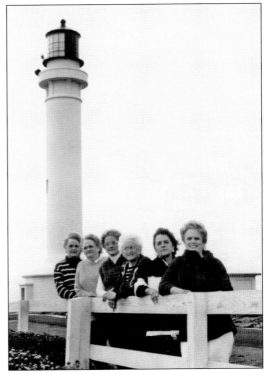

The Owens girls reminisce in 2004 during one of their annual reunions at the light station. Left to right are Joan, Sarah, Dixie, Shirley, Jean, and Diana. No doubt Sarah would recall the time she took her younger sisters Jean and Joan down into Devil's Punchbowl, a huge sinkhole just west of the fog signal building, or down the cliff across from the keepers' houses. In early 1930s, a keeper had fallen into Devil's Punchbowl and was washed out to sea. Always watchful of her daughters, mother Isabel was dismayed to hear about their risky adventures many years later. (Photograph by Dave Torres; courtesy Owens family collection.)

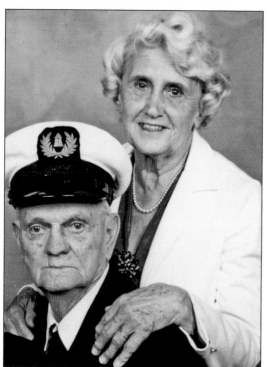

Bill and Isabel Owens remained at Point Arena Light Station until 1952, when they moved to Point Cabrillo Light Station. The couple eventually retired and moved to Little River, California. They enjoyed traveling and visiting their daughters. "Dad fished until he could no longer fish," recalls daughter Sarah. Bill Owens met the qualifications for a perfect light keeper: he was a mechanic, carpenter, plumber, electrician, and a good example for other keepers. He did whatever it took to keep the light station running efficiently. (Courtesy Owens family collection.)

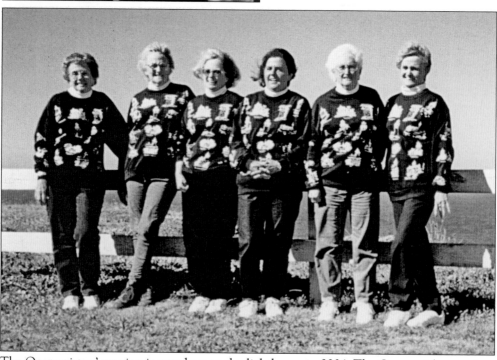

The Owens sisters' reunion is seen here at the lighthouse in 2004. The Owens girls grew into confident and capable women. In this photograph, they are wearing matching sweatshirts depicting West Coast lighthouses. Five of the Owens daughters married US Coast Guard men; the sixth married a Navy man. (Courtesy Owens family collection.)

Eight

US COAST GUARD
AT THE LIGHTHOUSE, 1939

In 1939, Point Arena Light Station, Point Cabrillo Light Station, the Coast Guard LORAN station at Point Arena, and the Coast Guard Life Saving Station at Arena Cove were united into one US Coast Guard unit. The commanding officer of the Life-Saving Station had authority over all. In this 1942 photograph, Coast Guard enlisted men Charles E. Rains (left) and Rolf Kenny (right) appear happy with their assignment to the lighthouse. (Courtesy Point Arena Lighthouse.)

In 1939, when the Coast Guard began operating the light station, assistant keeper Bill Owens had served at the lighthouse for more than two years. According to Isabel Owens, keeper Owens was not happy with the idea of having to join the Coast Guard to continue serving at the lighthouse. For a short time, Owens donned the uniform of the Coast Guard Reserves; at least it came with a warm woolen pea coat. In the photograph above, taken on the lighthouse gallery in 1942, Owens appears very confident again as a federal Lighthouse Service employee. (Courtesy Owens family collection.)

Bill Owens, center left, retired from the Lighthouse Service in February 1963 after 30 years of dedicated service. This image was taken during his retirement ceremony at Point Cabrillo Light Station. (Courtesy Owens family collection.)

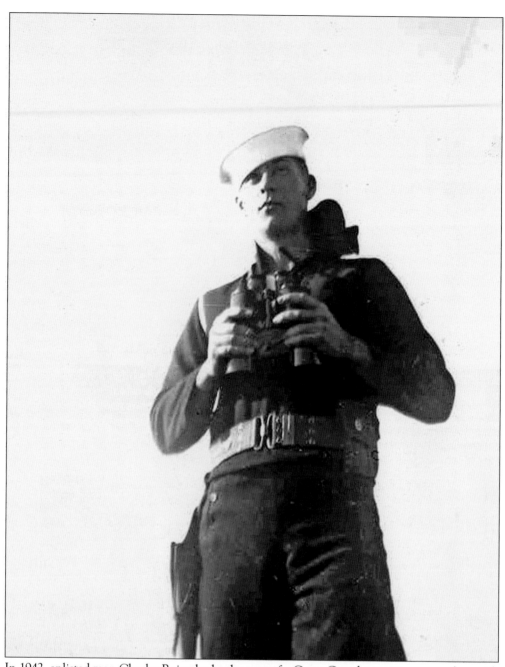

In 1942, enlisted man Charles Rains looks the part of a Coast Guard recruiting poster boy with binoculars ready to spot trouble offshore. During World War II, the Coast Guard operated patrols along West Coast beaches on foot, on horseback, and from lookout towers on the bluff tops. During Bill Owens's watch, he observed a Japanese submarine just off the point. The Navy opted to take no action on Owens's report; the next day, lumber schooner *Amelia* was torpedoed 50 miles north of Point Arena. (Courtesy Point Arena Lighthouse.)

Dale Andrew Beltz served at the Coast Guard LORAN station in Point Arena beginning in 1951. Beltz became a highly trained radio transmitter operator for the Coast Guard. On October 21, 1951, Dale Beltz married 16-year-old Shirley McMillen, daughter of Ralph and Sophie McMillen. Shirley, like her mother, developed a passion for storytelling and documenting historical events in her hometown of Point Arena. (Courtesy Shirley Zeni.)

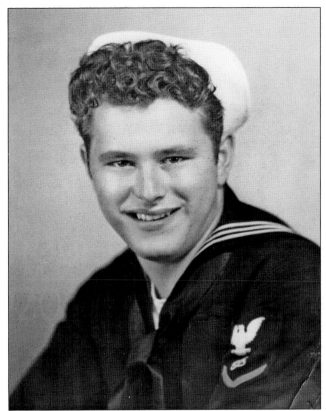

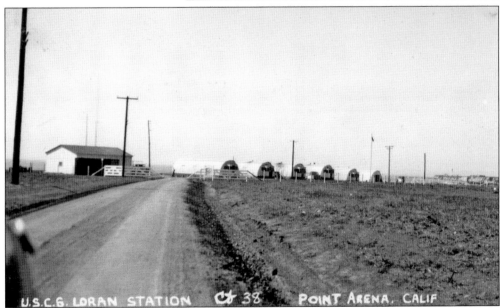

Pictured is the Coast Guard LORAN station garage and office with World War II–era Quonset-hut barracks in the background. Located on the headland a mile south of the lighthouse, the LORAN station was a beautiful site at which to be stationed, but for a young enlisted man, it was very isolated. (Courtesy Shirley Zeni.)

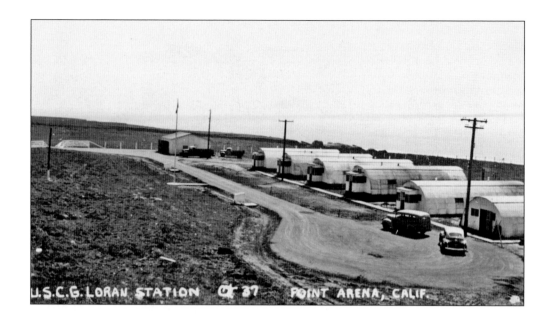

The enlisted men at the LORAN station lived in Quonset-hut barracks, as seen in the image above. Later, four wooden family units replaced the barracks. The station also used a Quonset hut for a recreation hall, galley, and dining hall. (Both, courtesy Shirley Zeni.)

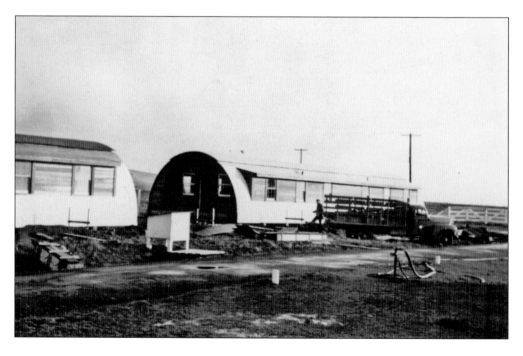

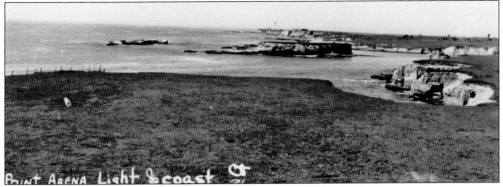

Point Arena Light & coast

This 1951 photograph was taken from the transmitter hut at the LORAN station looking across Stornetta Ranch toward Point Arena Light Station. The lighthouse tower is in the background. It is a magnificent view across more than 1,000 acres that are now Stornetta Public Lands. (Courtesy Shirley Zeni.)

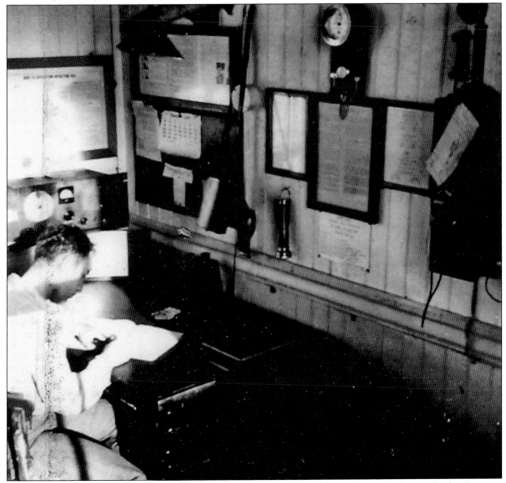

This is believed to be the radio room in the fog signal building at Point Arena Light Station when the Coast Guard operated the station in the late 1940s or early 1950s. The enlisted man is unidentified. (Courtesy Shirley Zeni.)

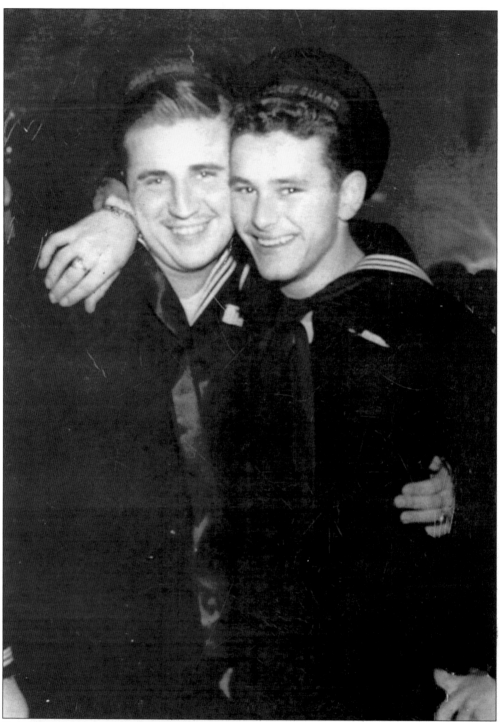

Dale Beltz (right) visits a friend, Smokey, from New York in January 1949. Beltz was 20 years old in this picture, taken two years before he was stationed at Point Arena. He was from Lincoln, Nebraska, and the Mendocino coast of California must have been a welcome assignment for him. (Courtesy Shirley Zeni.)

Nine

SAVING THE LIGHT, RENOVATION AND PRESERVATION

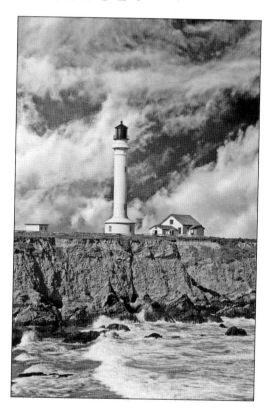

The Point Arena Lighthouse tower and fog signal building, where the lighthouse museum and gift store are located, are seen from a smaller peninsula on the light station grounds. A wooden gazebo stands on the small peninsula, a reminder of the time in 1992 when Warner Bros. filmed scenes for the movie *Forever Young.* In the film, the hero lands a World War II B-25 Mitchell bomber on the light station to connect with his lost love. The gazebo has since been the site of many happy wedding ceremonies. (Photograph by Ron Bolander.)

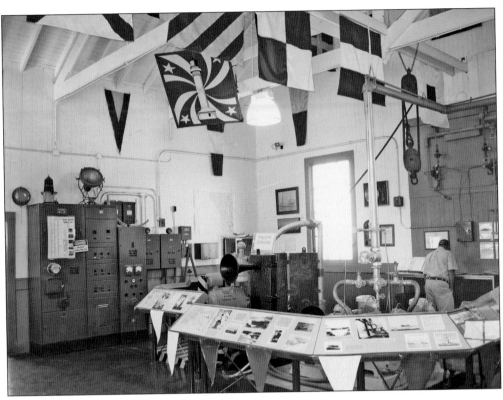

The lighthouse museum in the fog signal building (above) is shown before a major renovation project began in July 2008 with grant funds from the California Cultural and Historical Endowment (CCHE). The museum, near the end of the renovation of the building, is in the photograph below. First on the schedule was the disassembly of the Fresnel lens and drive mechanism in the tower. The pedestal in the center of the photograph is being prepared for the installation of the Fresnel lens. The round mercury bath and float on the right await reassembly onto a support column and will be installed in the museum. Photograph storyboards were rebuilt around a pony wall (below center) surrounding the lens and expanded along two walls of the room. (Photographs by Nicolas Epanchin; both, courtesy Point Arena Lighthouse.)

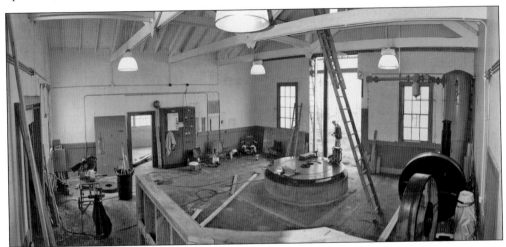

The Point Arena Lighthouse Keepers, Inc., (PALKI) grant-writing committee submitted drawings by Don Jacobs AIA, president of JZMK Partners, to the California Cultural and Historical Endowment. PALKI was awarded $200,000 to begin phase I of the renovation project. PALKI board members Nicolas Epanchin and Pauline Zamboni were project comanagers. After the disassembly of the Fresnel lens, the fog signal building renovation (pictured at right) was second on the project schedule. Worn roofing was replaced and a new red roof was installed by Redwood Roofers. Stark and Thornton Construction coordinated phase II of the renovation project. PALKI was awarded $1.209 million by CCHE to complete phase II, with a matching $334,000 required of PALKI. Exterior wall and foundation repairs were completed along with the construction of a new west wall, pictured below. The removal of this wall, damaged by years of extreme weather on the point, facilitated the safe placement of the Fresnel lens and mercury bath lens drive system into the museum. (Photographs by Nicolas Epanchin; both, courtesy Point Arena Lighthouse.)

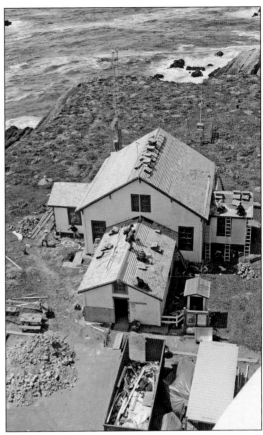

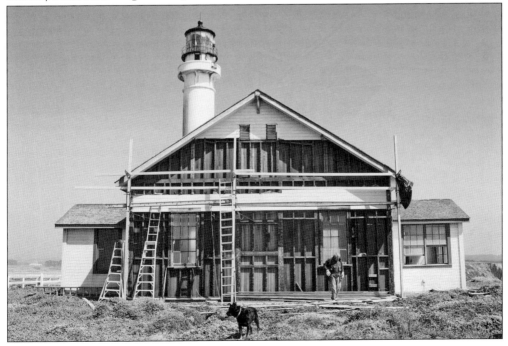

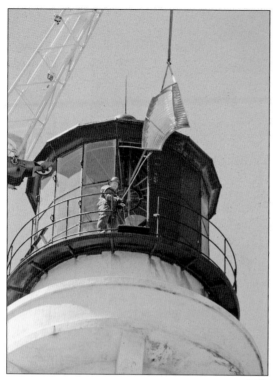

In the left image, lampist James Woodward, on the catwalk, steadies a section of the Fresnel lens. Twenty-four lens sections were carefully removed from the lantern room by a 135-foot boom controlled by a very experienced crane operator. This photograph shows a close view of a support corbel cantilevered out under the ledge of the tower gallery. In the bottom image, the 25-ton crane dwarfs the 115-foot-tall tower, next on the renovation schedule. (Photographs by Nicolas Epanchin; both, courtesy Point Arena Lighthouse.)

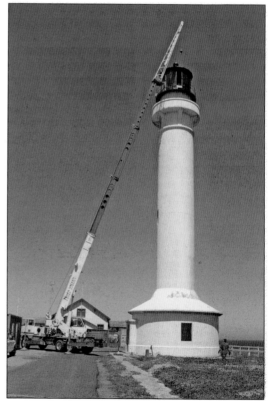

Pictured at right is the disassembly and removal of the lens system from the tower, its cleaning and storage, and its ultimate reassembly in the fog signal building museum, which were done by James "Woody" Woodward, owner of Lighthouse Consultant, LLC, and his associates, Kurt Fosburg and Jim Dunlap. (Photograph by Nicolas Epanchin; courtesy Point Arena Lighthouse.)

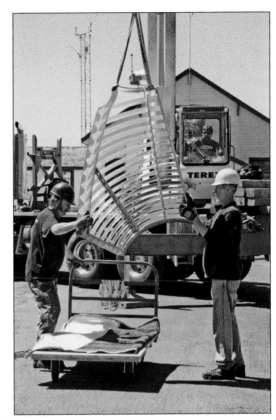

This photograph shows parts of the mercury bath and drive system after its removal from the top of the tower. From left to right, the parts are the drive shaft and support column, the platen, the float, the mercury bath, and the rectangular base. After being cleaned and painted a traditional green color, the parts were reassembled in the fog signal building in the background. (Photograph by Nicolas Epanchin; courtesy Point Arena Lighthouse.)

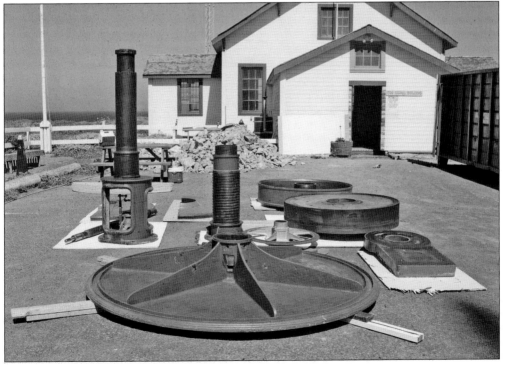

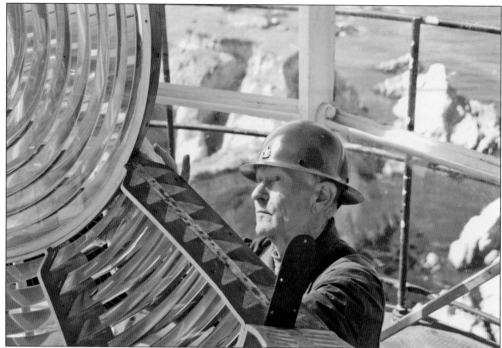

"Woody," above, is at work in the lantern room disassembling a section of a bulls-eye in the Fresnel lens. The three men work confidently securing lens pieces with straps and hook in preparation for lowering them out of the lantern room by a crane to a well-cushioned cart waiting below. Removal of a section of windows in the lantern room and careful planning enabled this amazing task to proceed with perfect execution. Randy's Custom Glass replaced all of the glass in the lantern room with new windows. (Photographs by Nicolas Epanchin; both, courtesy Point Arena Lighthouse.)

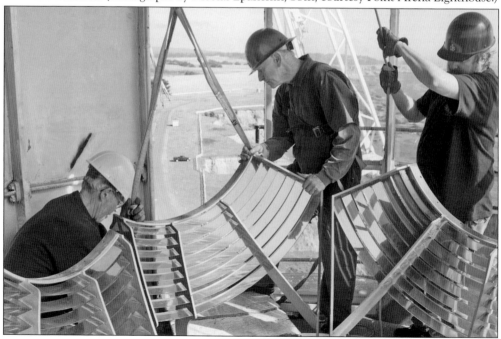

Woodward is working a bolt loose on the brass collar above the mercury bath float. Previously, 5.3 gallons of mercury were removed and sent for recycling in 2004 by lampist Woodward. Point Arena was the last American lighthouse to have its mercury float bearing drained. (Photograph by Nicolas Epanchin; courtesy Point Arena Lighthouse.)

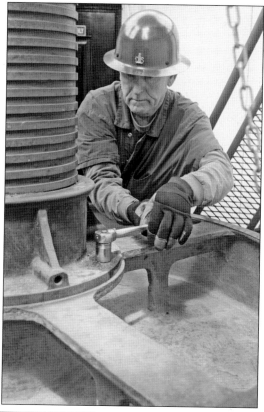

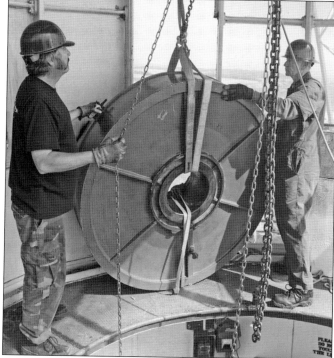

In this image, lens experts Fosburg (left) and Woodward (right) prepare to remove the float of the mercury bath from the lantern room. Note the absence of a floor in this photograph; the mercury bath drive assembly rose up from the watch room floor into the lantern room, where the Fresnel lens was mounted on the platen. (Photograph by Nicolas Epanchin; courtesy Point Arena Lighthouse.)

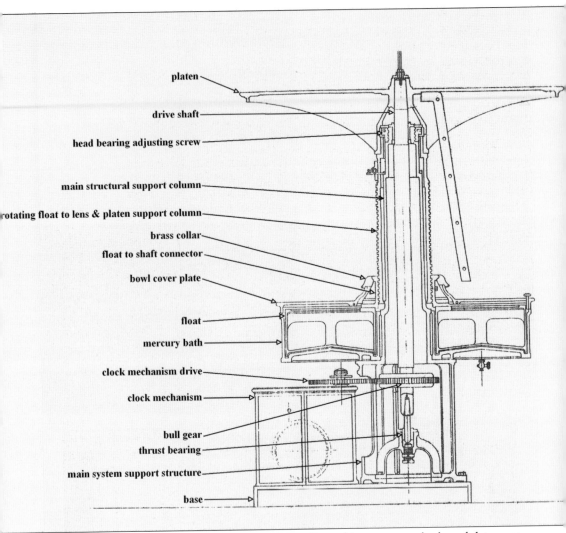

platen

drive shaft

head bearing adjusting screw

main structural support column

rotating float to lens & platen support column

brass collar

float to shaft connector

bowl cover plate

float

mercury bath

clock mechanism drive

clock mechanism

bull gear

thrust bearing

main system support structure

base

This diagram is a cross-section of the Point Arena Fresnel lens mercury bath and drive system. The clock mechanism, driven by a 160-pound hanging weight, is shown on the left side. (Courtesy James Woodward and Nicolas Epanchin.)

Kurt Fosburg, in the above image, applies a simple and direct method of thoroughly cleaning the clock mechanism with a special power-washer. In the photograph below, the cleaned and buffed clock mechanism looks like it did when light keepers spent hours cleaning and polishing the equipment at the lighthouse. It is ready for inspection in the new museum. (Photographs by Nicolas Epanchin; both, courtesy Point Arena Lighthouse.)

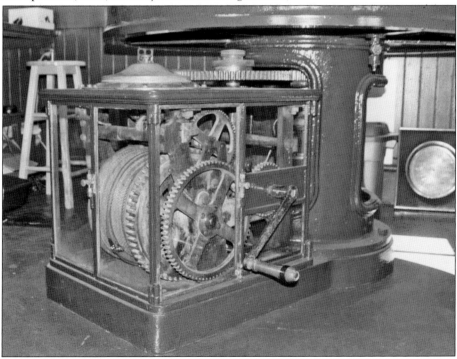

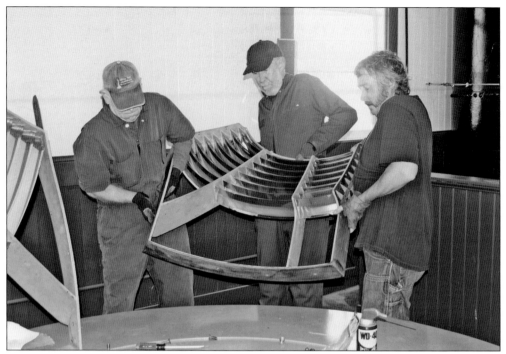

The three "lens restoration authors," above, lift a very heavy section of the lens into place for reassembly in the museum. The big, nine-foot-tall Fresnel lens was made by Barbier, Bernard, and Turenne and was shipped around the Horn from France in 1906 or 1907. The French used crown glass made from silica sand containing iron, giving the glass a distinctive green tinge. Below, from left to right, James Woodward, Kurt Fosburg, and Jim Dunlap pose before the nine-foot-tall jewel of a lens after installation in the museum is complete. (Photographs by Nicolas Epanchin; both, courtesy Point Arena Lighthouse.)

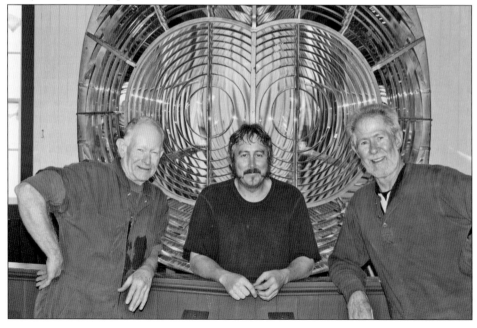

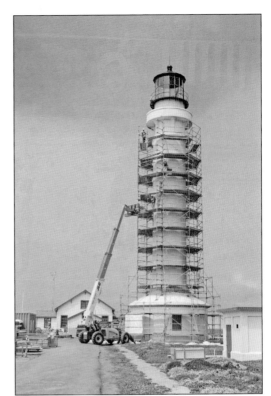

Pictured at right, the tower was surrounded by scaffolding by Thyssen Krupp Safway. For many months, the station was buzzing with the sounds of construction in the fog signal building and inside the lighthouse tower. In the bottom image, the 115-foot-tall tower is sealed in Eagle wrap like a gift awaiting presentation. (Photographs by Nicolas Epanchin; both, courtesy Point Arena Lighthouse.)

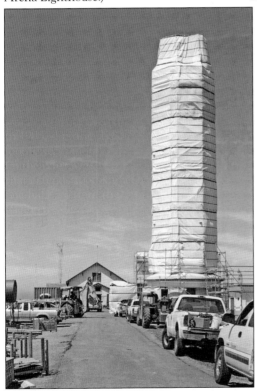

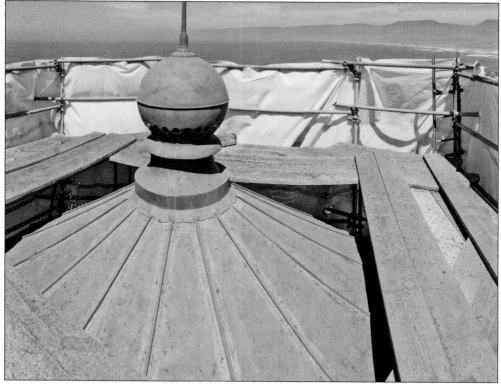

The copper dome (above), previously painted black, is exposed through Eagle wrap and surrounded by a wooden plank walkway to facilitate work on the 140-year-old roof. Serious corrosion problems were discovered after sections were lifted from the dome, necessitating the replacement of the expensive copper roof and delaying the completion of phase II of the renovation, which added considerably to the overall cost. In the photograph below, the new dome with a reused ball and lightning rod complete the crown of the tower. Thankfully, CCHE was able to grant an additional $235,000 to PALKI and required matching funds of $141,000. Ron Stark returned to the project from retirement, as Stark Construction, to complete phase III for the lighthouse. (Photographs by Nicolas Epanchin; both, courtesy Point Arena Lighthouse.)

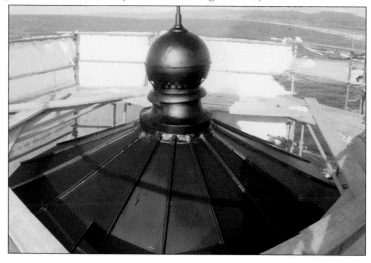

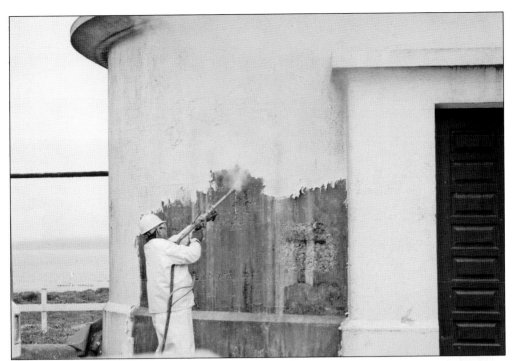

Pictured above, a test is performed by Certified Coatings to determine whether removing the old paint finish, sand, and encrusted salt from the tower was best done with 40,000-psi water-blasting or with sand-blasting. A combination of both methods was ultimately used to clean the exterior and interior of the tower. Numerous sites of deterioration in the concrete and integrated steel rods were discovered, especially in the buttress and gallery. The time-consuming process of patching, repairing, and replacing began. In the photograph at right, the tower stands unwrapped and coated with a waterproofing compound for temporary protection over several months until a parge finish and elastomeric coating could be applied. Costly scaffolding would be reerected for this last step, making the method of lowering a keeper with a large paintbrush in a bucket look so much easier. (Photographs by Nicolas Epanchin; both, courtesy Point Arena Lighthouse.)

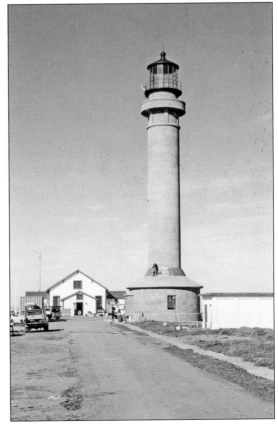

Major areas of the tower renovation were performed by Alpha Restoration & Waterproofing. The president of the company, Emile Kishek, is not pictured, though two employees, Joel Barcenos (left) and foreman Dimitris Tsinakis, are seen above. Through the winters of 2008 and 2009, the two spent many cold foggy days clinging to scaffolding and working diligently while the wind whipped and tore at the Eagle wrap. The company was given an industry Award of Merit for the project in 2012. Pictured below is James Riley of Fort Bragg Electric, who installed new electrical lines. Mehl-Bishop Electric handled the main power relocation. The south and north oil storage buildings were restored and have again become useful outbuildings. (Photographs by Nicolas Epanchin; both, courtesy Point Arena Lighthouse.)

Ron Hals (above), project foreman for Stark and Thornton Construction, works on the apron covering the seam at the top of the buttress. Before the tower renovation is complete, the apron will be covered with copper sections and painted black. Branesky Sheet Metal constructed the copper dome for the tower. Carpenter Joe Riboli (right) prepares a section of copper flashing to be installed on the buttress apron. This workstation is in front of the tower doorway. During the renovation, the fog signal building became a workshop for major repairs, and in better weather at the point, stations like this one were set up on the grounds near the tower and buildings much as it was done during the building of the tower in 1907 and 1908. During the renovation, plumbing repairs were done by Gale Van Curren, his excavations rivaling those of the active gophers on the point. (Photographs by Nicolas Epanchin; both, courtesy Point Arena Lighthouse.)

Contractor Stan Thornton (above) stands at the top of the lighthouse tower. In the bottom photograph, contractor Ron Stark, left, with Alpha Restoration & Waterproofing foreman Dimitri Tsinakis, right, sit on scaffolding in a wrapped section of the tower just below the gallery base, seen in the upper-right corner. The lighthouse was fortunate to have smiling men on the job. (Photographs by Nicolas Epanchin; both, courtesy Point Arena Lighthouse.)

At last, after a year and a half of work, the Point Arena Lighthouse tower and fog signal building (right) stand firmly on the point of land once named the Cape of Fortunes. Thanks to CCHE and grant funds totaling $1.644 million, plus careful planning by the PALKI board of directors, who were able to raise $475,000 in matching funds, the renovation and preservation of the station's historical buildings were completed in 2009. The light station is listed in the National Register of Historical Places. In the bottom image, the late John Wingate (left) and friend Jerry Erickson (right) stand west of the fog signal building. The two lighthouse supporters made a significant donation—copper for flashing and gutters on the fog signal building and for the apron on top of the buttress. (Photographs by Nicolas Epanchin; both, courtesy Point Arena Lighthouse.)

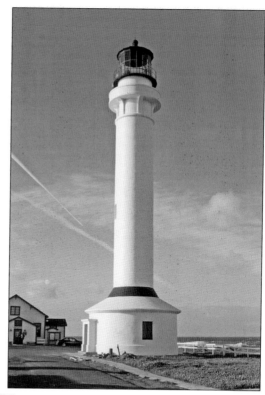

Pictured left, a US Coast Guard HH-65 Dolphin helicopter is on a training flight off the point in 2012. At the light station, where a Coast Guard refueling depot is located, the flags of the United States of America and the state of California, along with the lighthouse burgee, wave in a southern breeze. In recent times, the room on the south side of the fog signal building has been named the Whale Watching Room and the Natural History Room area of the museum. In the bottom photograph, the bright orange helicopter flies very near the tower. Keeper Bill Owens and his wife, Isabel, recalled seeing a blimp graze the lighthouse tower in the 1940s, then continue up the coastline, heading north. (Photographs by Ron Bolander.)

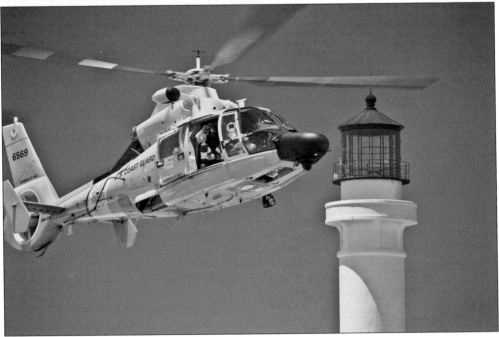

Coast Guard petty officer Clare Linder works on the modern VRB-25 beacon, moved to the west side of the lantern room on the metal catwalk railing. Both the primary beacon and the smaller back-up beacon were moved to this location on the exterior lantern room walkway in 2009. "The net effect of this move is the overall visible arc has been reduced by a little more than 40 degrees . . . enough to no longer be seen from some nearby northern and southern communities," states Nik Epanchin in his renovation synopsis in 2009. In 2012, an opaque panel was removed from the VRB-25 by the Coast Guard; now the lighthouse beacon can be seen at night from all directions. It continues to be a welcome sight to mariners. The lower photograph was taken from Stornetta Public Lands across the coastline, designated as part of the California Coastal National Monument. Point Arena Light Station is seen on the bluff top in the distance. (Photographs by Nicolas Epanchin; both, courtesy Point Arena Lighthouse.)

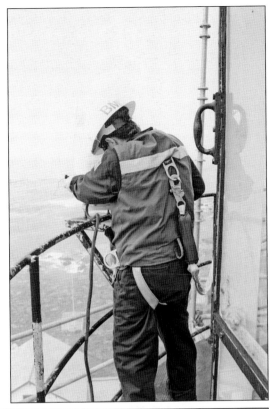

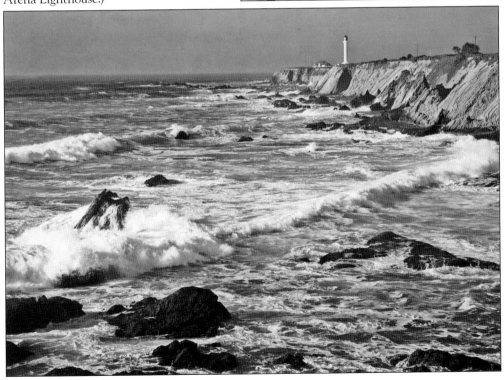

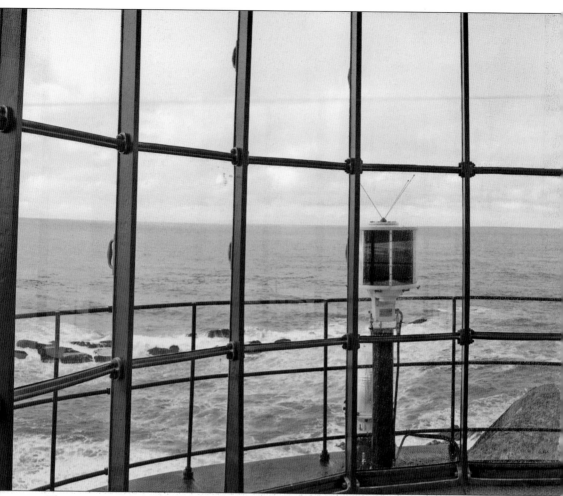

This is a magnificent view from the lantern room, looking west into Devil's Punchbowl on the tip of the peninsula. The US Coast Guard beacon is on the left. The room at the top has a large metal plate installed in the floor where the huge nine-foot-tall Fresnel lens, mercury bath, and drive system nearly filled the space. Extensive paint removal and cleaning of the bronze mullions around the new windows give a refined look to the lantern room. With the new copper dome,

there is a lustrous glow from the ceiling in the lantern room—an excellent location to catch a 360-degree view of the coastline. One can imagine a time when keepers, their families, and visitors looked out over the same ocean, rocks, and shoreline. (Photograph by Nicholas Epanchin; courtesy Point Arena Lighthouse.)

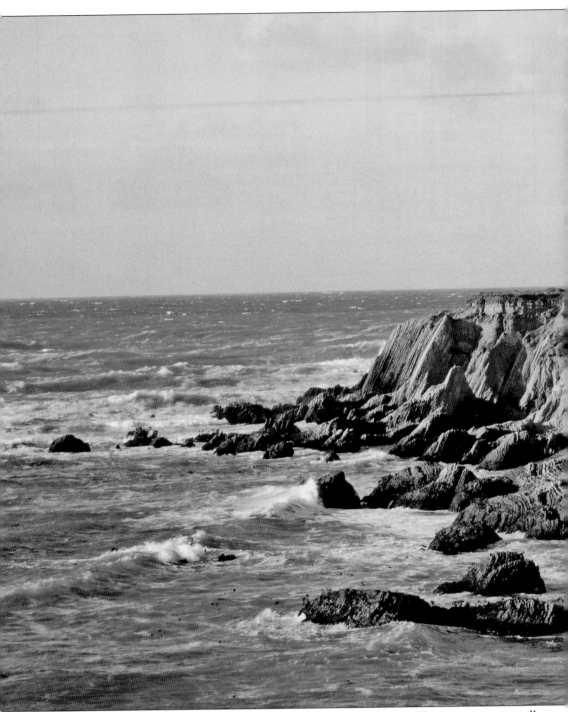

This image was taken on a beautiful day at Point Arena Light Station. The station was initially saved for the enjoyment of the public when, in 1984, Point Arena Lighthouse Keepers, Inc., was established by a group of local folks who loved the lighthouse. This group of diligent supporters acquired a 25-year lease on the property. The good guidance of head keepers; long hours of work by assistant keepers and their families; and, more recently, the dedication of board members,

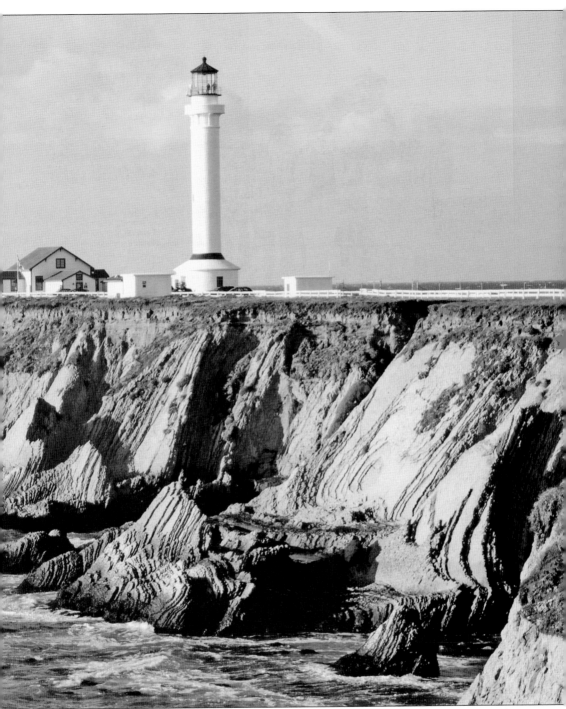

executive directors, staff, and volunteers has assured the preservation of Point Arena Light Station for the future. The buildings and essential equipment have survived many stormy years above the sea on the edge of the continent. (Photograph by Nicolas Epanchin, courtesy Point Arena Lighthouse.)

The Wind & Whale Celebration is a popular annual event at the light station in early March. The Berkeley Kite Wranglers fly giant kites on the windy headland, delighting local residents and coastal visitors. National Lighthouse Day on August 7 is another special day for visitors who enjoy climbing to the top of the tower. Six lodging cottages can be seen in the center of this photograph. They are very popular with couples and families who want to experience the adventure and relaxation of staying at the light station. Lodging is an important source of revenue for the station. (Photograph by Bob Carter; courtesy Point Arena Lighthouse.)

Chef Luciano Zamboni had the inspiration for the Save the Light events—a culinary celebration for Point Arena Light Station. As president of the board of directors, he envisioned bringing leading chefs together at the lighthouse to cook with him in an effort to raise funds for the Save the Light campaign. With a starring lineup of chefs, the first celebration took place on September 15, 2007, under a huge tent on the headland near the lighthouse tower, opening the light station's fundraising campaign to raise matching funds for the major renovation project that began in July 2007. (Photograph by Jeanne Gadol; courtesy Point Arena Lighthouse)

Guests enjoy a delicious dinner and music at a Save the Light event in 2007. The following year, the Save the Light event celebrated the 100th year of the 1908 lighthouse tower. A play was presented commemorating the occasion along with an extraordinary dinner menu that was typical of the turn of the century and jazz music reminiscent of the time when the new tower was opened. Themed celebrations for saving the light continue to be popular annual events on the coast. (Photograph by Jeanne Gadol; courtesy Point Arena Lighthouse.)

BIBLIOGRAPHY

Coan, Gregory W. "Point Arena." *The Keeper's Log* (1980): 2–13.

Epanchin, Nicolas. "Renovation Synopsis." *Point Arena Lighthouse Keepers, Inc., Docent Manual* (2010): 1–7.

Liles, Necia. "Point Arena Light Station." *Mendocino Historical Journal* 50, no. 2 (June 2011): 9–15.

Oliff, Steve, and Cheri Carlstedt. *The Early Days of Point Arena—A Pictorial History of the City and Township*. Point Arena, CA: Olyoptics, 2005.

Owens, Cora Isabel. "Lighthouse Memories—Part I, II, III." *The Keeper's Log* (1989): 21–27.

Riehl, Brian, and Steve Oliff. *Quake at Station 496—History of the Ruin and Reconstruction of the Point Arena Lighthouse*. Self-published, 2005.

Rogerson, Bruce, and the Point Cabrillo Lighthouse Association. *Point Cabrillo Light Station*. Charleston, SC: Arcadia Publishing, 2008.

Shanks, Ralph C., Jr., and Janetta Thompson Shanks. *Lighthouses and Lifeboats on the Redwood Coast*. San Anselmo, CA: Costano Books, 1978.

Weymouth, Kent Barclay. *Lighthouses of the Golden State—California's Shining Beacons*. Sacramento: Magpie Publishing, Inc., 2008.

Woodward, James. "Lightening Lights—The Mercury Float Lighthouse Lens: Its Development, Use and Decline." *Point Arena Lighthouse Keepers, Inc., Docent Manual* (2008): 30–37.

About the Organization

Point Arena Lighthouse Keepers, Inc. (PALKI), is a nonprofit, membership-based organization. The lighthouse, which is open to the public seven days a week, has become an important destination for approximately 40,000 visitors a year. The lighthouse is listed in the National Register of Historic Places with special significance in Architecture/Engineering and Event. Daily tour admissions, gift store sales, membership fees, and the rental of vacation cottages as well as revenue from Save the Light events all provide important income for ongoing preservation, facility upgrades, and educational endeavors. The light station is also available for private events. It is a site of natural beauty for weddings, movie filming, and other special events.

The mission of the Point Arena Lighthouse Keepers is to maintain in perpetuity the historic Point Arena Light Station—including the 23 coastal acres it encompasses, its 115-foot lighthouse tower, and its 1896 fog signal building—for the inspiration, education, and enjoyment of all generations to come.

Visit the Web site at www.pointarenalighthouse.com or call 877-725-4448 during daily business hours of 10:00 a.m. to 3:30 p.m. (10:00 a.m. to 4:30 p.m. in summer).

Discover Thousands of Local History Books Featuring Millions of Vintage Images

Arcadia Publishing, the leading local history publisher in the United States, is committed to making history accessible and meaningful through publishing books that celebrate and preserve the heritage of America's people and places.

Find more books like this at
www.arcadiapublishing.com

Search for your hometown history, your old stomping grounds, and even your favorite sports team.

Consistent with our mission to preserve history on a local level, this book was printed in South Carolina on American-made paper and manufactured entirely in the United States. Products carrying the accredited Forest Stewardship Council (FSC) label are printed on 100 percent FSC-certified paper.